IDITAROD

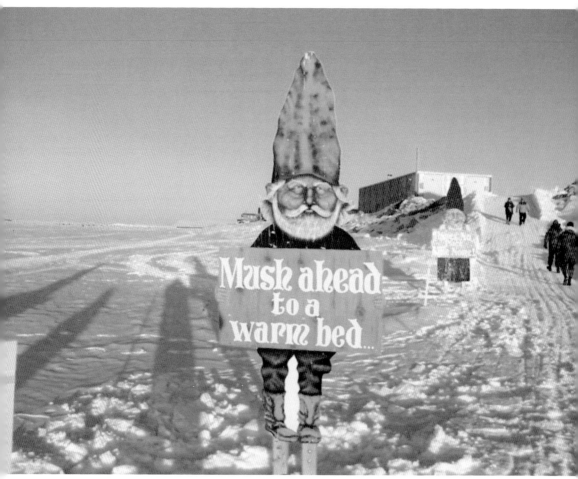

During the 2003 race, a series of gnomes were on hand to greet, encourage, and direct mushers. The messages were erected on the sea ice near the ramp that sends mushers up to Nome's Front Street. A few blocks farther along, they pass beneath the Burled Arch. (Barbara Lake.)

ON THE FRONT COVER: Repeat champion Jeff King is pictured at the Takotna checkpoint in 2006 as he was on his way to his fourth Iditarod win. Heavy breathing while running in below-zero temperatures can create ice on a musher's facial hair. (Jeff Schultz.)

COVER BACKGROUND: An eager team leaves the start line in Willow during the 2010 Iditarod Trail Sled Dog Race. (Frank Kovalchek.)

ON THE BACK COVER: After weeks of travel, the first dog team arrived in Seward from Nome on what was then called the Seward Trail. A party of five men traveling by dog team surveyed the route for the Alaska Road Commission (ARC) in the winter of 1908. Subsequently, the ARC spent $10,000 developing the route, which soon became widely known as the Iditarod Trail. (Library of Congress; photograph by S. Sexton.)

IDITAROD

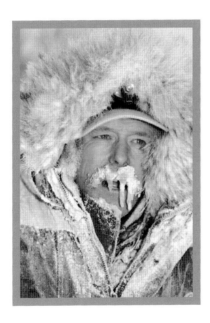

Tricia Brown
with a foreword by Jeff King

ARCADIA
PUBLISHING

Copyright © 2014 by Tricia Brown
ISBN 978-1-4671-3104-9

Published by Arcadia Publishing
Charleston, South Carolina

Printed in the United States of America

Library of Congress Control Number: 2013956054

For all general information, please contact Arcadia Publishing:
Telephone 843-853-2070
Fax 843-853-0044
E-mail sales@arcadiapublishing.com
For customer service and orders:
Toll-Free 1-888-313-2665

Visit us on the Internet at www.arcadiapublishing.com

To all you Iditarod people—the mushers and their families, handlers, race volunteers, administrators, and fans—who know life is not complete unless it is shared with sled dogs.

CONTENTS

FOREWORD

Alone with my dogs in the remote wilderness just north of Mount McKinley, I struggled to make sense of the scratchy AM radio reports of a sled dog race going on between Anchorage and Nome. How was it even possible? And who were the people doing this amazing thing?

The "why" was easier to figure out. I could imagine how it must feel to spend weeks with your dogs while crossing the expanses of this great state. Even then, I was living out a childhood dream: traveling by dog team, living in a tent, and running a trapline in one of the most remote and beautiful places I could ever imagine. It made me feel small, and I yearned to find out more about the people, the dogs, and the history behind the Iditarod Trail Sled Dog Race.

I was a young, twentysomething musher the first time I laid eyes on Joe Redington Sr., known as the "Father of the Iditarod," but the experience is still as clear today as it was that summer of 1980. I saw before me a short, pleasant individual who exuded an energy and spirit that no one could mistake for anything but confidence and tenacity. I found myself challenged to keep up with him as he ran up the rickety stairs in the back of Teeland's Country Store in Wasilla. I followed him into what was then the Iditarod headquarters above a dry goods, hardware, and tobacco shop. I was ready to do this thing.

By the winter of 1979, I had been in a few dog races, including the Gold Miners 140 from Nenana to Manley, where I raced against Iditarod champion Jerry Riley. There, I also met Joe Redington's son Joee, and his son. Joee was an accomplished sprint racer and had completed the Iditarod as well. As I sat around the parlor stove with the Redingtons in Manley, Joee lamented how hard it was to keep up with his dad's accomplishments. He explained to me how Joe Sr. had just summited Mount McKinley with a dog team and a young woman named Susan. I would later learn that she was the up-and-comer Susan Butcher, who went on to claim four Iditarod championships in her career.

"How can I ever top that?" he asked. "I guess I'll have to swim the English Channel with my dog team and an 18 year old." Still, Joee's gruff account of his father's endeavors did not hide the pride he had for his dad.

After leaving Settler's Bay on the first Saturday in March 1981, I headed to Nome in my wool pants and wool shirt—the warmest clothes of the time—and had packed a good ol' Coleman cookstove in my sled (makes me wonder what that packed sled weighed in comparison to my sled this year). When the countdown was finished and my team blasted from the start line, I was struck by the reality of 1,000 miles of trail in front of me. Had there not been teams ahead of and behind me, I would have said it could not be done. The mantra "four on, four off"—the alternating hours of run and rest time—was ringing in my ears as 13 of the 14 dogs I owned were out in front of me, charging up the trail.

Who were the people who had dreamed this up? And how was it that they had allowed me to join them? Rick, Jerry, and Herbie; Sonny, Susan, and Libby; Emmitt, Ken, and Gerald: the list

has grown over the years to include incredible individuals with a combined set of cunning, grit, and perseverance that was unmatched by any group I have ever met.

Like a revolving door, my first race wore on. As I grew drunk with fatigue, it was hard to tell dream from reality. The flicker of a headlamp or the twinkle of a star? Village lights or a campfire in the distance? They twinkled and were gone. Dream or reality? I could not be sure. Chills from the arctic cold seeped through faulty zippers. Thirst burned and the water bottle froze. The dogs trotted on. Where were the other teams? Who was ahead? How far to the checkpoint? Did we miss a turn in the trail? The dogs trotted on.

Then, unmistakably, the lights of the village and the smell of wood smoke confirmed our arrival. The dogs picked up their pace. The lure of a warm spot to lie down, dry socks, and hot Tang pushed us on.

The sensory memory is still vivid for me, even though the experience took place more than three decades ago. And we're still coming back.

The lure of the Iditarod Trail runs deep. The trail makes us feel whole. The dogs make us feel loved. The adventure nourishes our soul.

—Jeff King
Denali Park, Alaska
Iditarod Champion—1993, 1996, 1998, and 2006

ACKNOWLEDGMENTS

Our warm thanks go to the Iditarod Trail Committee, Inc. (ITC); Stan Hooley; Joanne Potts; Diane Johnson; Jeff Schultz; Jeff King; Lance Mackey; Dick Mackey; Dan Seavey; Vern Halter; Ramey Smyth and Becca Moore; Chuck and Shirley Newberg; Rose Albert; Ellen Donoghue; Gale Van Diest; Jon Van Zyle; Frank Kovalchek; Kjersti M.G. Mjærum; Barbara Lake; KYUK-FM; Theresa Daily; Libbie Martin; and Clark Fair. Special thanks to Jeff Ruetsche, Sara Miller, and the team at Arcadia Publishing.

Many of the early-20th-century images in this volume are now in the public domain courtesy of the Frank and Frances Carpenter Collection, a 1951 gift to the Library of Congress (LC) by Frances Carpenter, who donated the collection under her married name, Mrs. W. Chapin Huntington. Unless otherwise noted, all images are courtesy of the author.

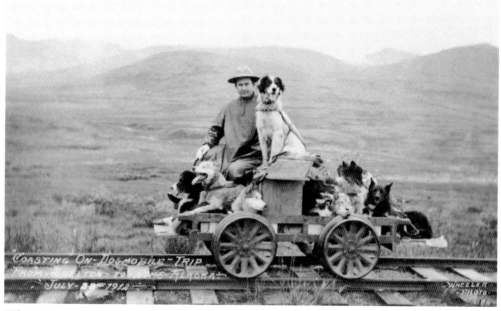

When miners, explorers, and other settlers arrived in Alaska, they quickly learned the wisdom of harnessing dogs' power for their own purposes. Walter W. Johnson, a mining engineer and gold-dredge designer based in Nome, traveled between mining camps via the family "dogmobile" and on horseback. Johnson noted on this July 28, 1912, photograph that "when it was time to coast, the dogs would jump aboard without command." In 1910, there were about 92 miles of narrow-gauge railway and 32 miles of standard-gauge railway connecting various gold camps and communities on the Seward Peninsula. (LC.)

INTRODUCTION

He who gives time to the study of the history of Alaska learns that the dog, next to man, has been the most important factor in its past and present development.
 —Judge James Wickersham, from his book, *Old Yukon: Tales, Trails, and Trials*
 Third Judicial District, Alaska, 1938

Iditarod. The word is a tongue-twister, a name associated with Alaska's last great gold rush, a resulting boom town, a historic trail and, beginning in 1973, an extraordinary physical and mental challenge: a 1,000-mile sled dog race across Alaska that pits top teams from around the world against each other . . . and themselves.

Correctly pronounced "eye-DIT-uh-rod," the word is cited as the Ingalik Athabascan place name for a great river in southwestern Alaska, but that's a distortion of the original name, which was even more challenging to the Western tongue, recorded and rerecorded variously as *Tachaichagat, Yachzikatna, Khadilotden, Haidilatna,* and *Haiditarod.* Non-Native settlers put it on record as "Iditarod" on a 1908 US Geological Survey map; upon the discovery of gold that year, many thousands poured into the district to make money in mining or in businesses that supported the miners, and the area boomed with activity and trade. The Seward-to-Nome Trail (later called the Iditarod Trail) saw lots of action as horses and dogs moved people, mail, and supplies into the area and people, mail, and gold bars out of it.

According to the Bureau of Land Management, which helps oversee the Iditarod National Historic Trail, "the Iditarod goldfields became the fourth most productive district in all of Alaska . . . over 65 tons of gold, or $1.77 billion dollars at today's value, was taken out of the Iditarod district—most of it was taken out by dogsled."

It would be a mistake to think of the historic Iditarod Trail as a single line on a map. Rather, it was a system of Alaska Native trade routes, dog-team mail trails between mining camps, frozen river ways, and portages—some of them centuries old and some blazed when new towns popped up. Mile Zero of the historic Iditarod Trail lies on Resurrection Bay at Seward, a town that formed in 1903 as plans rolled out for the Alaska Railroad. The spot was an ideal location as a year-round, ice-free saltwater port. From there, railroad builders planned to lay track northward to Fairbanks and the Interior gold fields, following the existing trail until the railway skirted Cook Inlet.

With most booms, there's usually a bust. By 1918, within a decade of the Iditarod discovery, the gold rush started to fade, and mail carriers bypassed the shrinking town of Iditarod. Young men were called away to World War I, and roadhouses and other support systems began to shut down. The Wells Fargo dog sled "gold trains" made their last runs to Seward. The boom had ended; the trail fell into disuse and, in time, was virtually unrecognizable in places.

Then, in 1967, a revival began. A small core of pioneers purposed to reopen a portion of the trail in the Wasilla-Knik area for inclusion on a new sled dog race route. Dorothy G. Page and

Joe Redington Sr., both of whom cherished the pioneering roots of Alaska's dog-mushing history, joined forces to create a two-day race. Redington was a musher himself and lived on a Knik homestead along the old Iditarod Trail. Page was a Wasilla townie, a community organizer, who helped to get people pulling in the same direction, as Joe did with his dogs. Across the state, snow machines and airplanes had replaced the roles of dogs, and Page and Redington wanted to reverse that trend—to introduce a new generation to the sport of sled dog racing. With a cadre of helpers, they raised money for a $25,000 purse and put together the Iditarod Trail Centennial Sled Dog Race in February 1967, timed to celebrate the 100th anniversary of the purchase of Alaska from Russia. It was so much fun that the mushers wanted to do the local race again, and a group of 10 each pitched in $1,000 and ran it again in 1969. However, it was still not the Iditarod we know today.

Among the mushers in Nome, the Fairbanks area, and Southcentral Alaska, there was always talk of something more, but nothing really happened until 1972, when Redington posed the question, "Why not mush from Anchorage to Nome?" His words fired imaginations in mushing circles—both in the Bush and the cities—and Redington carried the talk with him when he traveled. He had a way about him, everybody agreed, of getting people on board with big ideas. With the support of Page and many other key people at both ends of the historic Iditarod Trail, the 1,000-mile race was born in 1972 and run for the first time in March 1973. In time, Page and Redington would be labeled "Mother of the Iditarod" and "Father of the Iditarod," respectively, and the old Iditarod Trail, once an essential way to transport millions in gold, would become associated with the pinnacle of competitive dog mushing.

For more than four decades, the epic competition known as the Iditarod Trail Sled Dog Race has started in Anchorage and finished in Nome. Everyone involved—from the competitors to those handling the logistics—has learned much about how to run a race. It has evolved into a machine of enthusiastic volunteerism overseen by seasoned leaders. If the Iditarod racers and organizers have learned anything, it's this: it's much more than just a race or the finish-line images seen on televisions and computer screens. The Iditarod represents some of the best of Alaska's history and heart.

The champions and record-breakers certainly get their due. The preparation, as well as the race, is epic, and the dogs are wonders. But the race would not happen without the people working behind the scenes. These pages feature the thousands who have stepped up to help throughout the 40-plus years of the race, including a man holding a clipboard in remote Shageluk, forgoing sleep and withstanding frigid conditions to meet and check in mushers through the wee hours of the morning; the Takotna families who ensure that every hungry musher passing through their village will be overstuffed with crab, steak, turkey, moose stew, and chili; a veterinarian who left her thriving practice in Iowa for two weeks and paid her own way to join an army of like-minded dog doctors, including some who have never known the grip of below-zero temperatures; and Bush plane pilots who put dozens of extra hours on their personal aircraft to move loads of food, straw, sleds, and other supplies to checkpoints all along the race route. Televisions and webcams do not show the dog handlers, the sandwich-makers, the old man who skims ice out of the river waterhole to keep it open, or the teenager walking around with the shovel to pick up dog poop.

All year long, these volunteers go about their business, living with their eyes on the calendar, waiting for the first Saturday of March, prepared to serve the dogs and their mushers, eager to spend time with friends old and new, and ready to join in the thrill of The Last Great Race.

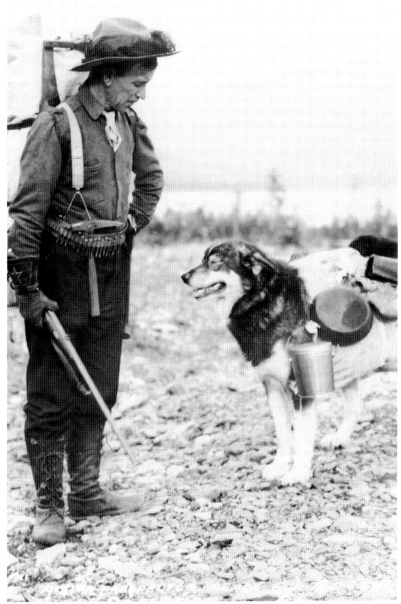

At Seward, the southernmost point on the historic Iditarod Trail, a man and his dog prepare to set out for a hunting trip into the Bush, with each of them carrying a portion of their camping equipment. Note that while the man wisely has mosquito netting on his hat, durable leather boots and gloves, a rock hammer, a gun, and ammunition, he has not forgotten to don a tie as well. This mixed-breed husky was common for a pack dog, with a large frame capable of carrying heavy loads. In harness, a dog this size could pull 100 pounds. (LC.)

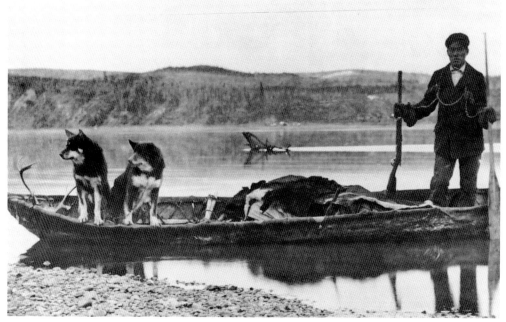

For centuries, Alaska Natives kept dogs as working animals and companions to assist with the daily hard work of living off the land. Above, an Athabascan man wears a combination of western and Native clothing as he and his dogs return from a successful caribou-hunting trip in a traditional boat. Below, Alaska's Eskimo people, the Yup'ik and Iñupiat, also counted on strapping dogs to help in everyday life, using a travois or cart when there was no snow on the ground. In winter months, the dogs would be part of a small, strong team that could haul water and wood for the family and lead men on trapline routes. (Both, LC.)

1

GOLD, MAIL, AND MORE

In the 1800s, the Iditarod region was sparsely populated by Athabascan families who hunted, trapped, and fished there for uncounted generations. Dog teams did the heavy work of moving wood, water, supplies, and game meat. Outsiders arrived in lapping waves—a Russian missionary here, a handful of fur traders there, a party of explorers, and then . . . a tidal wave of gold miners.

From Fortymile country to the Klondike, from Nome to Fairbanks, prospectors behaved like schools of fish, moving almost as one to chase rumors of gold. In 1908, word came that prospectors John Beaton and Bill Dikeman had found "color" on a tributary of the Iditarod River. The partners had used the winter drift-mining method to get down to the pay streak. The method involved building a bonfire to melt the icy soil, mucking it out, panning for gold, and then building another fire. After two dozen test shafts, the duo finally struck gold at 12 feet at Otter Creek on December 25, 1908—the precious metal was their Christmas Day gift.

By summer, miners were flooding into the region. Steamboats delivered passengers and freight via the Yukon River to the Innoko and Iditarod Rivers. Another nearby gold strike fired another stampede. Camps sprang up—Poorman, Dishakaket, Dikeman, Discovery, and Willow Creek— with Iditarod as the hub. In the middle of nowhere, the boomtown of thousands boasted hotels, stores, restaurants, bars, and brothels. It was a modern city with three newspapers, electricity, and telephone service.

Newcomers had seen the value of a dog team during earlier rushes and copied the wisdom of the first arrivals. The federal government contracted with dog-team mail carriers to move post and freight on winter trails that connected the far-flung goldfields of western Alaska. Dog mushers moved food, equipment, mail, people, and gold.

In 1910 and 1911, the Alaska Road Commission spent $10,000 to construct the Seward-to-Nome trail (later dubbed the Iditarod Trail) with a branch to the Iditarod goldfields. Millions in gold moved through Iditarod's Miners and Merchants Bank and was transferred by dog team to Seward—a three-week trip on the Iditarod Trail—to meet oceangoing ships headed south.

An ancient route, the Kaltag portage, connects the Yukon River village of Kaltag with the Bering Sea coast to the west. It is part of a network of western Alaska trails that include the historic Iditarod Trail. Illustrator H.W. Elliott made this 1866 etching, titled "Sledding Kaltag Portage," from his travels with a US Geological Survey expedition. (Iditarod National Historic Trail.)

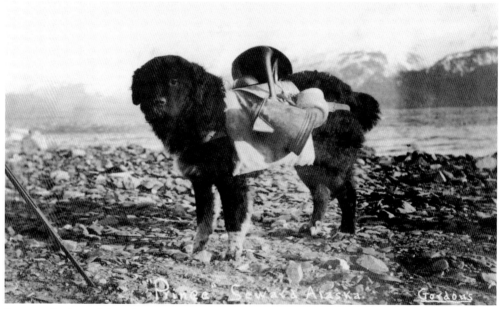

Prince, a big-boned dog who assisted an unidentified gold miner, is pictured here in Seward at the start of the historic Iditarod Trail. Prince is saddled with a sturdy pack and many of the odds and ends necessary to a miner who is planning to work the streams with a gold pan. (LC.)

GOLD, MAIL, AND MORE

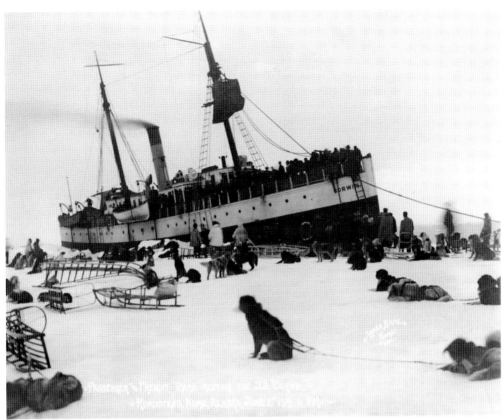

At Nome, dogs were essential to moving freight and people off ships when shore ice was still present. Above, passenger and freight teams met the SS *Corwin* on June 1, 1914. Although it was 11:00 p.m., Alaska's midnight sun was bright. The *Corwin* originally served as a US Revenue cutter in Arctic waters; in 1900, she was sold as a merchant vessel and for years was welcomed as the first ship of the year to Nome after breakup and the last to leave. Below, the view from the deck of the *Corwin* shows teams that traveled five miles over the ice to meet the ship offshore on June 1, 1907. (Above, LC, photograph by Lomen Brothers, Carpenter Collection; below, University of Washington libraries, Frank Nowell Photograph Collection, photograph by F. H. Nowell.)

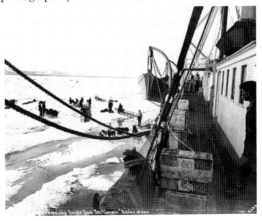

Bulk supplies in this 1911 trip included Quaker Puffed Wheat, Puffed Rice, Quaker Oats, and Uneeda Biscuits. Freight dogs were supersized and powerful, as dependable as workhorses but more agile and easier to feed with meat and fish. As times changed and dogs became more valued for speed and long-distance endurance, the mixed-breed huskies were bred to be smaller and lighter. (LC.)

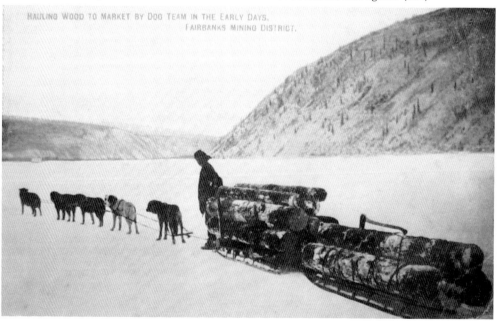

This 1910 postcard depicts a Fairbanks Mining District musher and his team hauling logs. Below-freezing temperatures in the subarctic region creates perfect snow conditions for moving heavy loads. Snowfall in this semi-arid region does not hold as much moisture as in other areas of the territory, allowing sled runners to slide more efficiently.

GOLD, MAIL, AND MORE

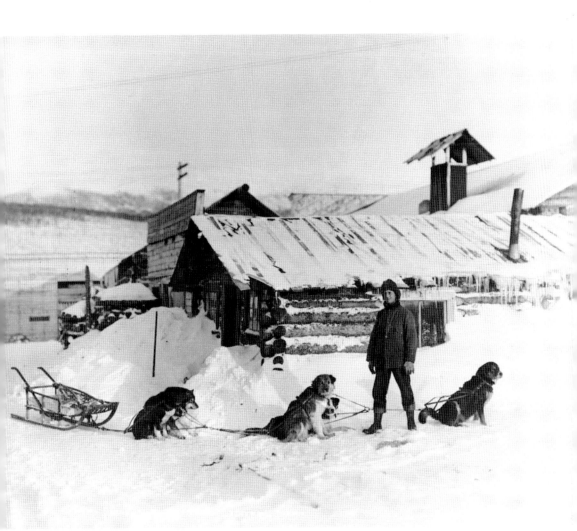

Iditarod resident Sam Adams pauses for a portrait with his team outside his log home. The town of Iditarod virtually sprang up overnight and was a transportation hub in western Alaska for a short time. The Alaska Road Commission (ARC) reported that the following road-miles had been constructed and maintained as of 1913: wagon roads, 862 miles; winter sled roads, 617 miles; and trails, 2,167 miles. (Alaska State Library, Basil Clemons Photographic Collection, P68-138.)

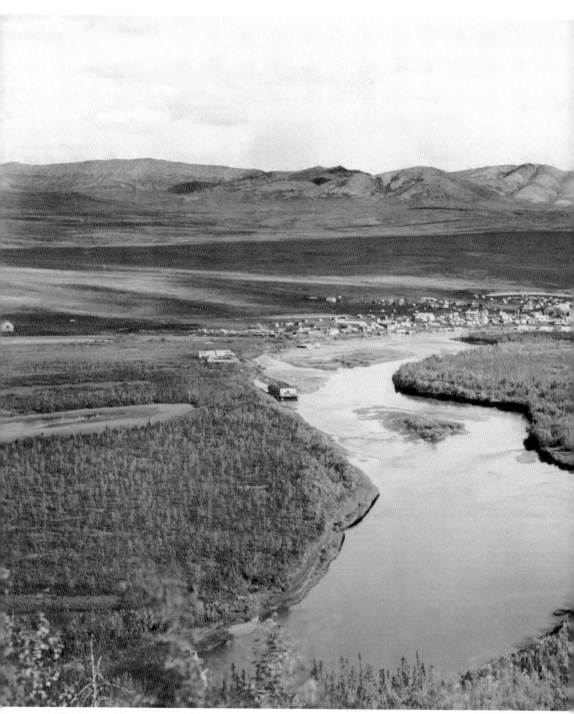

The Iditarod River is part of the Innoko River drainage. The mining hub town of Iditarod developed on the river's cut bank, where steamboats had enough draft to come close to shore. New arrivals created a city in the wilderness, with electricity, telephones, rail service to nearby Flat, and winter transportation as far as Nome to the north or Seward to the south. Between 1908 and 1925, about

GOLD, MAIL, AND MORE

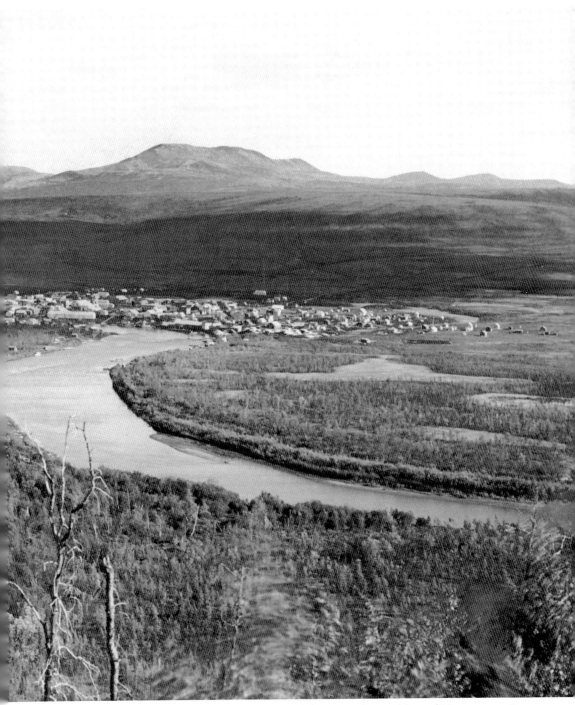

$35 million in gold was taken out of the district, and that was when gold was $20 an ounce. By 1930, gold recovery had dramatically dwindled, and many had moved on. Some buildings were transported to Flat. Today, only remnants remain in the ghost town. (LC.)

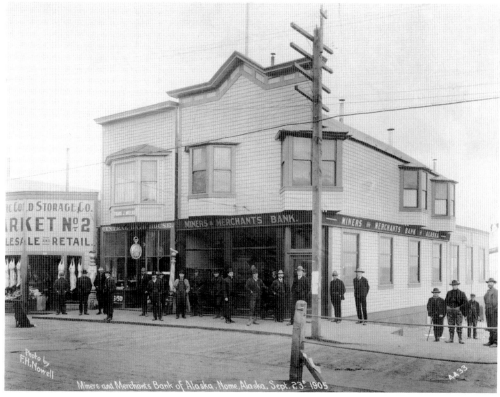

Nome's Miners and Merchants Bank was a stately building, as seen in this image from September 23, 1905. In the years after the gold was depleted, Iditarod became a ghost town. The vault from the Iditarod branch of the Miners and Merchants Bank remains among the ruins. (University of Washington libraries, Frank Nowell Photograph Collection; photograph by Frank H. Nowell.)

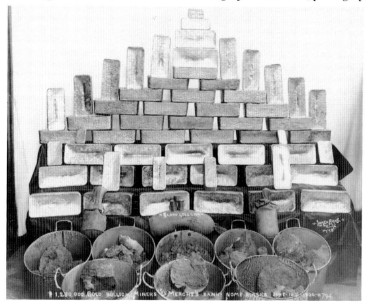

A magnificent display of $1,250,000 in gold bullion was photographed at the Miners and Merchants Bank of Nome on June 10, 1906. In 1910, the Miners and Merchants Bank had offices and holdings in Nome, Iditarod, and Ketchikan. (LC; photograph by Lomen Brothers.)

GOLD, MAIL, AND MORE

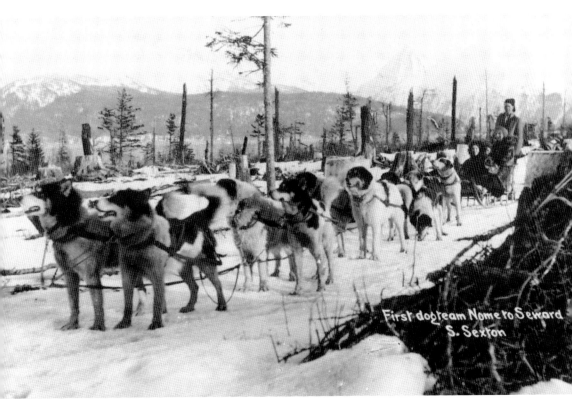

This team, identified on the photograph as "First dog team, Nome to Seward," traveled on what was first called the Seward Trail and, later, the Iditarod Trail. The Alaska Road Commission invested $10,000 to develop the route following a detailed survey by Army colonel Walter Goodwin and a party of four in 1908. Their report included this description of their route: "The Alaska Central Railroad was followed to its end at Mile 54, thence via Turnagain Arm, Glacier Creek, Crow Creek Pass, Eagle River, across country to Old Knik, across Knik Arm to New Knik across country Susitna Station, up the Susitna three miles, up the Yentna, Swentna [sic] and Happy Rivers, Pass Creek to Rainy Pass, down the Dalzell, Rohn and Kuskokwim Rivers to near the Tonzona, across country to the mouth of the Tacotna [sic] at McGrath's [sic], up the Tacotna and across country to the Tacotna Slough, over rolling hills to Gane Creek, down Gane and across country to Ophir Creek (the Innoko district), across country to Dishakaket and thence across country to the Kaiyuk Slough to the Yukon, and then up the Yukon to Kaltag, and by the Overland Mail Trail via Unalakleet to Nome." From the Susitna onward, this is virtually the same route followed by Iditarod dog teams today. (LC; photograph by S. Sexton.)

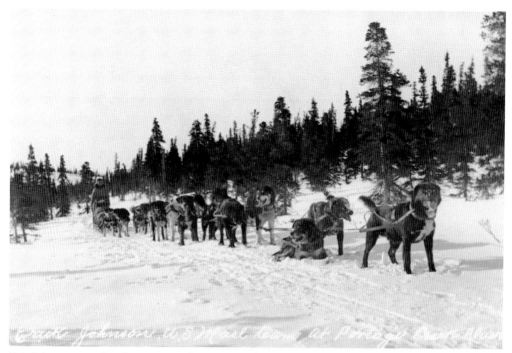

Eric Johnson was the dog-team mail carrier on the Nome-Unalakleet route in the first decade of the 20th century. Here, Johnson's team is pictured on Portage Creek on the Seward Peninsula. Times changed quickly. In 1924, the *Associated Press* reported that pilot Carl B. Eielson was making $2 per mile—or about $200 per hour—flying mail on the 350-mile route between Fairbanks and McGrath, calling him "one of the best paid men in the aerial mail service." Eielson's plane and any repairs were paid for by the government; he was responsible for his own fuel, oil, airfield, and hangar. The last dog-team mail driver was Chester Noongwook of Savoonga, on St. Lawrence Island; he retired in 1963. (LC.)

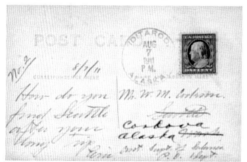

This piece of mail, from Eric Johnson himself, is postmarked August 7, 1911, from Iditarod. The card reached its addressee after a trip to Seattle and back to Cordova, Alaska—thousands of miles of travel. From the 1890s until as late in 1963, dog teams transported mail in Alaska, with the average team carrying 500 to 1,000 pounds of mail sacks, packages, and gold. In 1914, mail carriers transported more than 1,000 pounds of gold from Iditarod to Seward in 37 days. The image on the reverse side (above, right) shows horses breaking the snowy trail. The sender wrote on the image, "A stretch of mine road with your friend Eric on the box." (Photograph by Basil Clemons.)

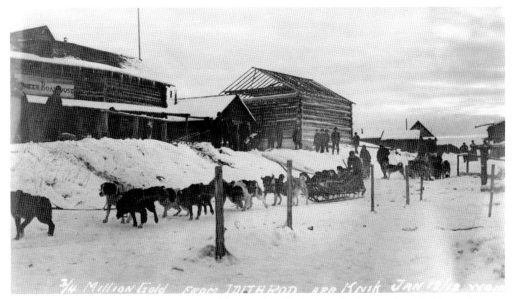

A dog team carrying some $750,000 in gold arrived in Knik from the Iditarod goldfields on January 12, 1912. Iditarod was 375 miles to the northwest, making Knik an important supply point and jumping-off place for gold speculators. Situated on Cook Inlet, Knik was easily accessed by water from Seward; at one time, 1,500 people lived there. Knik quickly declined after the 1915 founding of Ship Creek (now Anchorage), and construction of the railroad line that bypassed the little town. By 1920, Knik was empty. (LC.)

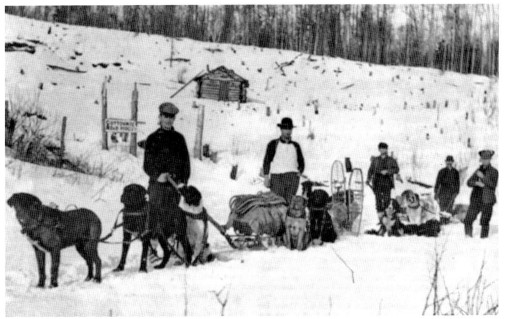

Cottonwood Roadhouse at Knik was one in a string of establishments with food and accommodations for travelers, dogs, and horses. Entrepreneurs built roadhouses, situated about a day's worth of travel apart, along Alaska's trails and wagon roads in the early 1900s. (Bureau of Land Management.)

The network of mail trails throughout Alaska included a segment that followed nearly the entire Yukon River, as well as a south-central Alaska section connecting the Susitna River with Seward, the site of the start of the Iditarod Trail. A 1912 report from the US Department of the Interior chronicled the territory's major transportation corridors: "The Kuskokwim Valley and the Iditarod section . . . are more poorly provided with transportation than the Yukon and Tanana Valleys . . . a winter sled road has been built from the end of the Alaska Northern Railroad at Kern Creek, on Turnagain Arm, up the Susitna Valley, and across the divide into the Iditarod region." Here, a mail team rests in Seward after driving in from the Susitna River drainage. (LC.)

GOLD, MAIL, AND MORE

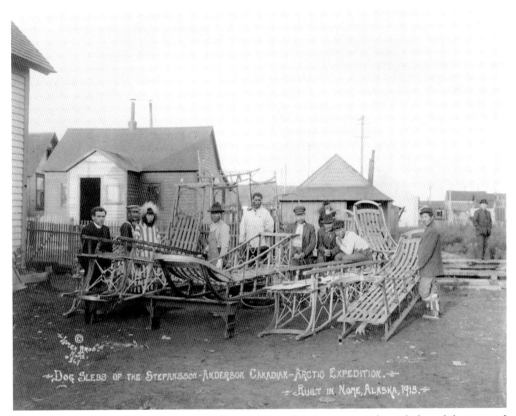

Dog Sleds of the Stefansson-Anderson Canadian-Arctic Expedition. Built in Nome, Alaska, 1913.

Arctic explorers relied on Alaskan huskies as well as Alaska Natives' knowledge of the ice and land. In Nome, Native sled builders supplied freight sleds to Vilhjalmur Stefansson and zoologist Rudolph Martin Anderson, leaders of the Canadian Arctic Expedition that began in 1913. Local kennels fulfilled the quota of sled dogs needed to support the two legs—northern and southern—of the scientific expedition. The expedition principally traveled via the flagship HMCS *Karluk*; however, sled dogs were vital for traveling overland. (LC; photograph by Lomen Brothers.)

Non-Native sledbuilders put into print the Native designs that had previously been handed down through oral instruction. This detailed freight sled schematic from Alaska is dated 1899 or 1900. (National Archives.)

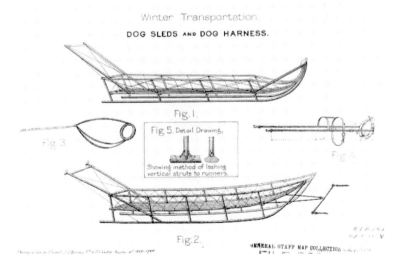

Winter Transportation

DOG SLEDS and DOG HARNESS.

Fig. 1.

Fig. 3

Fig. 5. Detail Drawing.

Showing method of lashing vertical struts to runners.

Fig. 4

Fig. 2.

GENERAL STAFF MAP COLLECTION

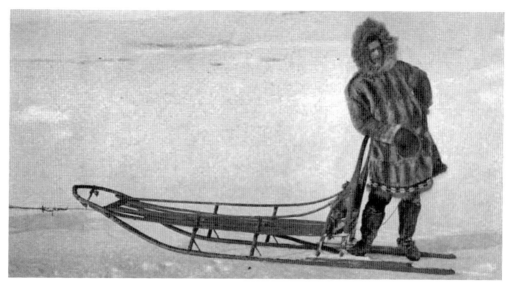

In the early 1900s, the Nome Kennel Club organized numerous sled dog races, making dog drivers and their lead dogs famous across the country. In 1931, A.A. "Scotty" Allan (pictured) wrote about Nome's All Alaska Sweepstakes in his autobiography, *Gold, Men, and Dogs*: "It was as big an event in Alaska as the Kentucky Derby is to the racing world. The betting was always very heavy. Sometimes there was as much as $130,000 on the books, with hundreds of side bets for lesser amounts." This image is from the book *Baldy of Nome* by Esther Birdsall Darling.

As Nome's champion mushers and dogs gained national prominence, Scotty Allan and Esther Birdsall Darling formed a partnership in the Allan and Darling Kennel. They organized and supplied working and racing dogs of such caliber that when the country entered World War I, the kennel operators were called upon to assist in the war effort, selecting scores of dogs to move supplies over the mountains of France and Germany. In his autobiography, Allan claimed to have trained more than 450 sled dogs for the military effort. French army captain René Haas (pictured) came to Nome to work with Allan on dog selection. Behind him are large freight sledges and other supplies ready for transport to a ship. This image is also from *Baldy of Nome*.

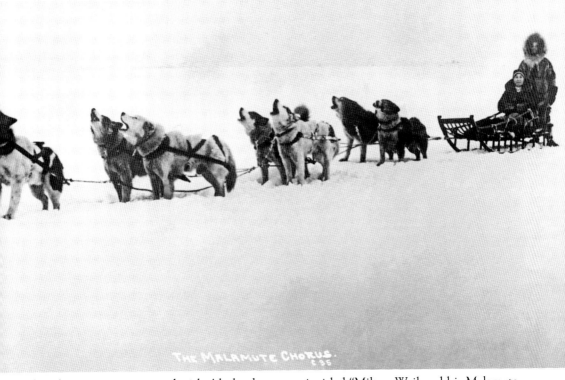

The Malamute Chorus.

This classic image associated with Alaska dog teams is titled "Milton Weil and his Malamute Chorus." It was taken by early Nome photographer B.B. Dobbs; this photograph and others by Dobbs were acquired in 1908 when three brothers—Harry, Ralph, and Alfred Lomen—bought out a photography studio in Nome. The Lomen brothers became partners in 1908, with Harry as manager and Alfred as the main photographer. With the purchase, they also acquired pictures taken by Dobbs and several other photographers. Lomen Brothers images, including many dog-mushing photographs, are prized in collections all over the country. (LC.)

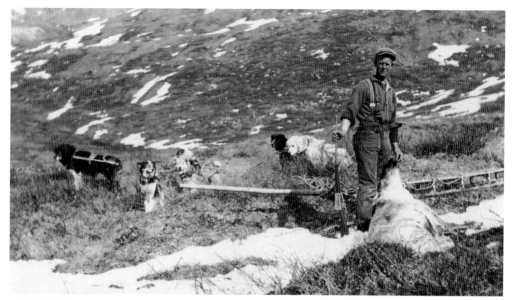

In this 1910 image, a team of dogs stands ready to haul a caribou kill for a McKinley Park meat hunter. Patrolling the national park has been a job for dog teams since the 1920s, and today, Denali National Park and Preserve continues the tradition of operating a working dog kennel year-round. No snow machines are allowed in the park, so rangers mush dogs while patrolling for poaching or other illegal activity inside its boundaries. Tourists enjoy interpretive dog-team demonstrations at the kennel in summer months and can visit remote shelter cabins built decades ago for backcountry mushers. (LC.)

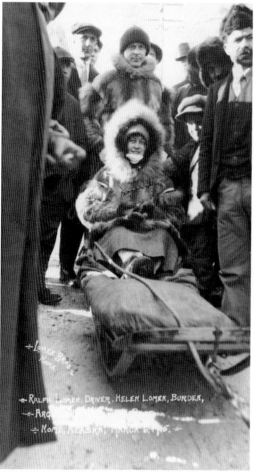

In 1915, Ralph Lomen entered a sled dog race that required a passenger in the sled as a "burden." In this case, he chose his sister, Helen. (LC.)

2

NOME'S ALL
ALASKA SWEEPSTAKES

On April 23, 1898, a trio of immigrants called "The Lucky Swedes"—Erik Lindblom, John Byrnteson, and Jafet Lindeberg (who was actually Norwegian)—discovered gold near Nome. A hope-fueled frenzy known as a "rush" drew 20,000 people to Nome by 1900—a boom that lasted only a few years before the get-rich-quick folks left; others stayed to make a life in the far north. By 1920, the population of Nome had settled at around 900.

In the intervening years, a mature city bloomed on the edge of the continent. Freight-haulers and miners, proud of their working dog teams, raced each other, and the Nome Kennel Club formed near the end of 1907. The most thrilling race of all was the All Alaska Sweepstakes, held in early June, which was a 408-mile round-trip from Nome to Candle.

The All Alaska Sweepstakes was the toast of the north from 1908 to 1917, with a strong local fan base and eager followers in the continental states. On race days, Nome was draped in patriotic bunting. Team owners and mushers sported team colors. Some people placed bets, and cheering fans packed the streets.

Celebrity mushers included John "Iron Man" Johnson, A.A. "Scotty" Allan, Leonhard Seppala, and Fay Delezene. Their dogs were equally famous. Baldy, Boris, and Navarre appeared in the children's books written by their owner, Esther Birdsall Darling; and Seppala's Siberians—Togo and Balto—held important roles in the Nenana-to-Nome serum run of 1925, when 20 teams relayed life-saving serum to head off an outbreak of deadly diphtheria. The heroic mushers and dogs covered 674 miles in five days and made national headlines.

World War I and gold depletion both helped lead to the end of the All Alaska Sweepstakes. In late 1916, the *Associated Press* reported that, "Thousands of dollars changed hands on the races every year. When Nome was at its height in the old gold boom days, the All-Alaska purse amounted to $10,000. Pioneers say $200,000 was wagered on the result one year."

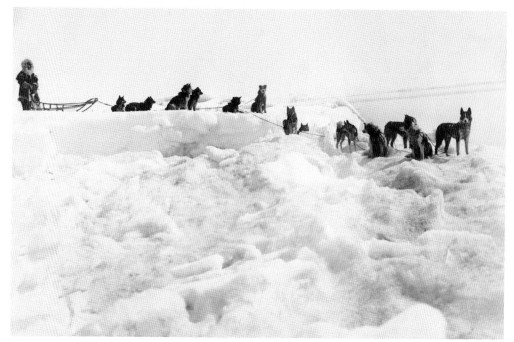

Stacked shore ice off Nome created a dramatic setting for this portrait of an unidentified musher and his team. During the first decades of the 20th century, Nome was the epicenter for national sled dog competitions and captured the imaginations of newspaper readers across the country. News from the goldfields was equally thrilling. During the 20th century, at least 3.6 million ounces of gold were extracted from the ground around Nome, including the city's sandy beachfront. (LC.)

The Nome Kennel Club organized in 1907 to formalize oversight of the Nome-area dog derbies; the years that the club organized the All Alaska Sweepstakes are recognized as the height of the gold-rush dog-team era. The club stayed loosely organized even after the big race was cancelled upon the advent of World War I and during subsequent years, when snow machines and airplanes took over the roles that dogs once held in the Far North. (Nome Kennel Club.)

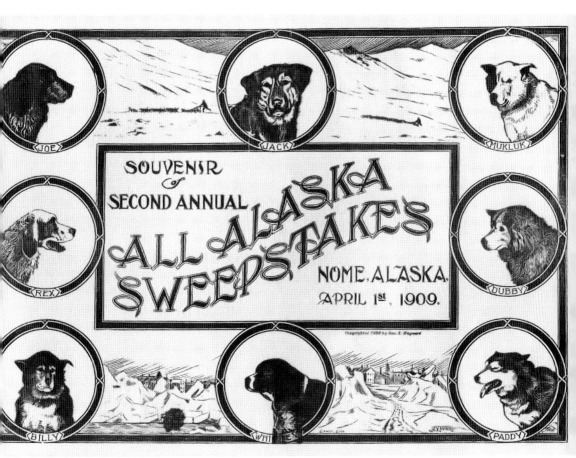

This program for the second annual All Alaska Sweepstakes (AAS) listed itself as "the first of its kind ever printed in the world"—an all-Alaskan publication that was conceived, written, illustrated, and printed in Nome. The valuable leaders of the day—Jack, Mukluk, Joe, Billy, Whiskey, Paddy, Rex, and Dubby—graced the cover and were the subjects of brief biographies inside the program. Each musher flaunted his team's colors. The Nome Kennel Club offered a purse of $10,000 and a silver cup to the first-place finisher, $2,500 for second place, and $1,000 for third place. The silver cup was to change hands until a champion won two races in a row. In a salute to its early roots in the AAS, the Iditarod Trail Committee reprinted this program in 1969.

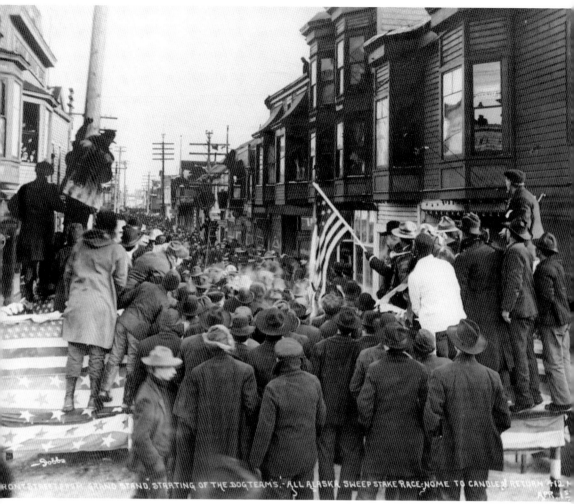

Bunting and fur decorated the platform at the start of the first All Alaska Sweepstakes. On the start day, April 1, 1908, it was −15 degrees Fahrenheit in Nome. Albert Fink won the race, with a team led by Jack, in 4 days, 23 hours, 15 minutes, and 12 seconds. A storm delayed the starts of some teams for as much as 24 hours. Race rules required that mushers return with all dogs that started with them, even if there was a dog or two riding in the sled. This image is from the book *Baldy of Nome* by Esther Birdsall Darling. (Photograph by B.B. Dobbs.)

NOME ALASKA.

From Nome (pictured here in 1916), teams proceeded north and east across the Seward Peninsula on a route that took about five days. Trail dangers included temperatures dropping as low as –50 degrees Fahrenheit, howling blizzards, and winds of such velocity that a team could be blown sideways. Still, there was shelter along the way, and mushers could make contact with towns. "Excellent telephonic communication with a score of places along the trail traveled by the teams makes it possible for Nome to keep in almost constant touch with them," wrote George S. Maynard, editor of the *Nome Nugget*. (LC.)

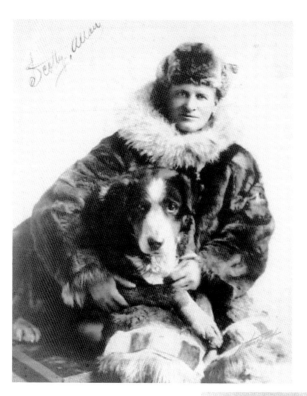

Allan Alexander Allan, better known as "Scotty," was one of the great champions of his day—a savvy businessman, dog breeder, and musher. He is pictured at left with his great leader, Baldy. Allan won the 1911 race in 81 hours and 40 minutes and the 1912 race in 87 hours and 32 minutes. During the 1914 race, the *Associated Press* reported: "All the teams are in good condition, but Allan's appear freshest. When he unhitched his dogs at Candle, they began to romp and frolic in the snow." Between 1908 and 1915, Allan took two first places, two second places, and two third places in the All Alaska Sweepstakes. This image is from the book *Baldy of Nome* by Esther Birdsall Darling. (Photograph by B.B. Dobbs.)

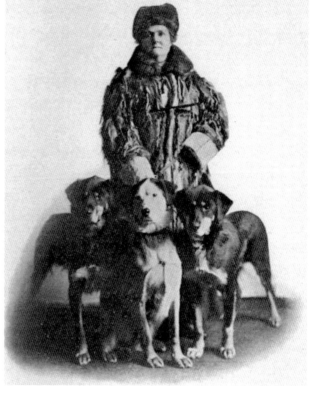

Esther Birdsall Darling (pictured at right) partnered with Scotty Allan to form Allan and Darling Kennel; the pair co-owned the teams that he trained and raced. Allan's famous lead dog became the subject of Darling's book, *Baldy of Nome*. She later penned two more children's chapter books: *Boris, Son of Baldy*; and *Navarre of the North*. This image is from *Baldy of Nome*. (Photograph by B.B. Dobbs.)

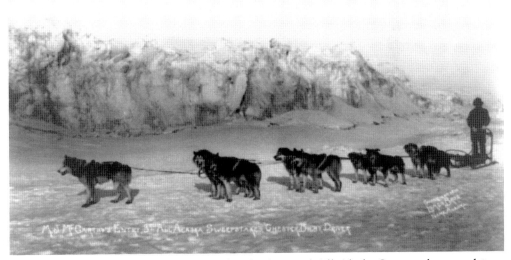

Michael J. McCarthy's entry (above) in the third annual All Alaska Sweepstakes was driven by Chester Bilby. Journalists of the day described the Nome-area dog racers as having "the best brain and brawn, the greatest strength and perseverance, the most indomitable determination, superb courage and tireless energy, combined in the humankind of the great broad Territory." Fox Maule Ramsay owned the team of Siberian huskies (below) that was driven by John Johnson, who finished the AAS in second place in 1910. Various dog teams were comprised of purebred Siberian huskies, McKenzie River huskies, hounds, pointers, Alaskan malamutes, Newfoundlands, mixed-breed huskies, St. Bernards, and even Irish setters. (Both, LC.)

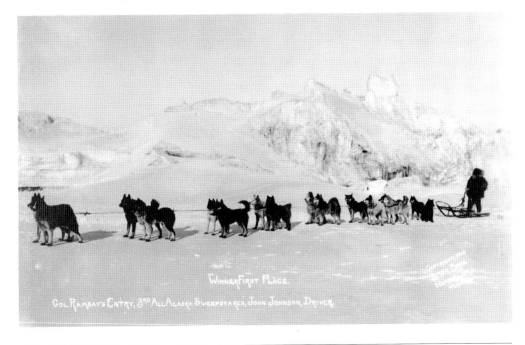

Russell W. Bowen (left) and Fay Delezene, both miners with the Pioneer Mining Co. of Nome, were co-owners of the winning team, with Delezene as driver, in the 1913 All Alaska Sweepstakes. Delezene covered that year's 412-mile route in 75 hours and 18 minutes. The *New York Times* account of the race included details on other competitors as well: "John Johnson's Siberian wolves, which set the record of 74 hours, 14 minutes and 20 [*sic*] seconds in 1910, were second and the dogs owned by Mrs. C.E. [Esther] Darling of Berkeley, Cal., and A.A. 'Scotty' Allan, third." That year's $5,000 purse was divided, with 60 percent going to the winner, 25 percent to second, and 15 percent to third. (LC.)

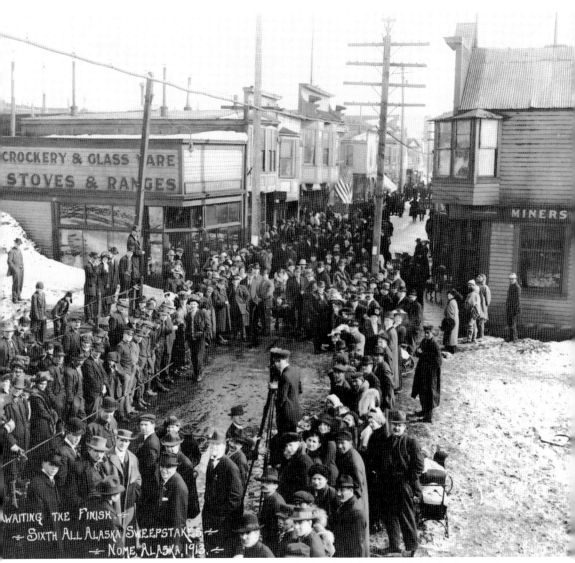

The streets of Nome were packed with people awaiting the finish of the 1913 All Alaska Sweepstakes, the sixth running of the race. The Washington-based *Tacoma Times* reported: "The race, which was one of the most exciting ever run in the North and upon which record-breaking bets were placed, began Thursday morning at 9 o'clock. [Fay] Delezene, who had trailed [John] Johnson all the way until the last few hours, was wildly welcomed when he drove into Nome with all of his racers on their feet. Two thousand people, virtually the entire winter population of Nome, had assembled on the snow to see the finish, and when the Delezene dogs came into sight, the crowd went wild." (LC.)

John "Iron Man" Johnson's record was untouchable in the early 20th century. In 1910, he set the course record of 74 hours, 14 minutes, 37 seconds. In 1913, he set a separate record in the Nome-to-

NOME'S ALL ALASKA SWEEPSTAKES

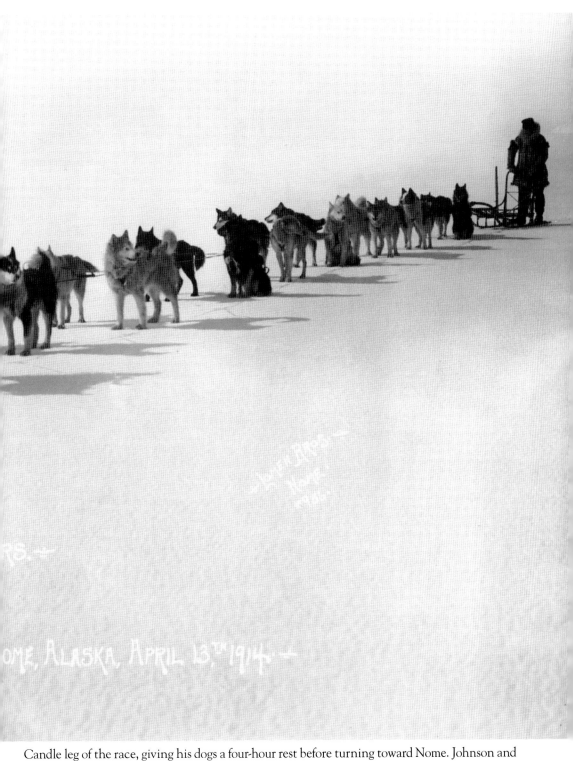

Candle leg of the race, giving his dogs a four-hour rest before turning toward Nome. Johnson and his team of Siberians are pictured here after winning the 1914 All Alaska Sweepstakes. (LC.)

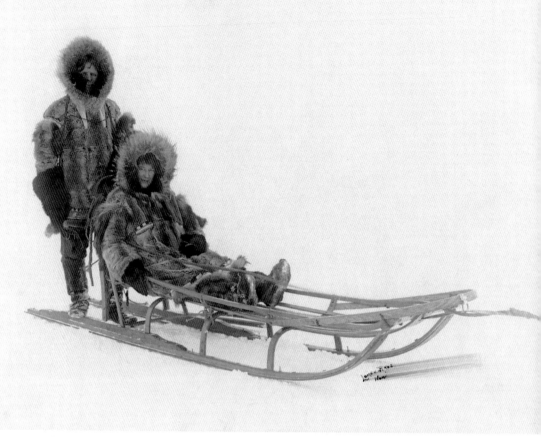

Leonhard Seppala (standing) is pictured here with his wife, Connie. Seppala was a Norwegian emigrant who worked for fellow Norwegian Jafet Lindeberg (a "Lucky Swede") at the Pioneer Gold Mining Company. Like miner-mushers in other camps, Seppala ran and cared for the company's dog team—beefy dogs used mostly for drayage. He was caught up in the competitive spirit among the camps that questioned which men and dogs had the most strength and endurance. In 1913, Arctic explorer Roald Amundsen, another Norwegian, had planned to launch an expedition to the North Pole from Nome, traveling with a team of Siberians, or "Chukchi huskies." When the expedition was cancelled, he gifted the team to Seppala, who entered them in the 1914 All Alaska Sweepstakes but had to scratch. However, Seppala's lightweight "Siberian racers" won the next three races—the last three before the end of the famed All Alaska Sweepstakes. (LC.)

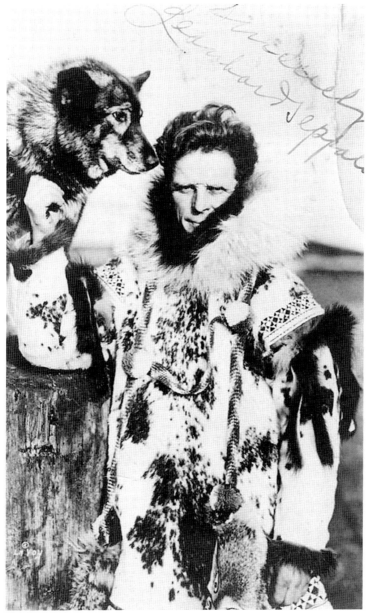

Leonhard Seppala, pictured here in the mid-1920s with his famous leader, Togo, had three consecutive wins in the All Alaska Sweepstakes (1915, 1916, 1917) with teams of Siberian huskies. Nome was not insulated from the effects of World War I. In November 1916, the *Associated Press* reported in papers throughout the country that the Nome Kennel Club had cancelled both the All Alaska Sweepstakes and the Solomon Sweepstakes: "The wide flung sweep of the world war in its relation to sport has penetrated beyond the Arctic Circle and the classic dog derbies have been abandoned until the return of normal times and conditions . . . although the big races are abandoned, dog drivers remaining in Nome for the winter will hold several short informal race meets during the long dark months coming. Possibly after the war the big races will be resumed."

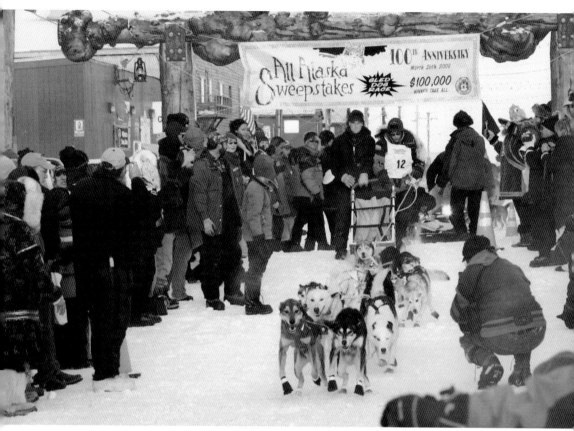

The Nome Kennel Club was revived as the Iditarod Trail Sled Dog Race began to take shape. Club members and other community members generously contributed toward the purse and paid many expenses to arrange for equipment and supplies at the Nome end, checkpoint needs, a finishers' banquet, and other events around town. In 1983, the NKC organized a 75th anniversary running of the All Alaska Sweepstakes, attracting 23 mushers who each paid $1,000 in gold as an entry fee. Champion Rick Swenson took the $25,000 purse. In 2008, an All Alaska Sweepstakes was held to recognize the centennial of the famous race. NKC organizers offered a $100,000 winner-take-all prize, which was won by Iditarod champion Mitch Seavey of Seward, who is pictured above as he and his team leave the start line. The 1910 record held by All Alaska Sweepstakes champion John "Iron Man" Johnson was shattered by six 2008 AAS mushers. (Theresa Daily.)

3

SPRINTING TOWARD ALASKA'S 1967 CENTENNIAL RACE

Dog mushing was all about speed in the mid-20th century. Using fast dogs and lightweight sleds in multiday sprint races, mushers had another chance tomorrow to make up for time lost today.

In the mid-1960s, Dorothy G. Page of Wasilla conceived an idea for a race that would accomplish two purposes. First, it would honor the centennial of Alaska's purchase from Russia, giving Wasilla a way to join the statewide celebration. Secondly, the event would draw attention to the nearby Iditarod Trail and to Alaska's grand history of mushing.

Page did not mush, but she knew how to motivate people, and she loved pioneer history. One musher in particular, Joe Redington Sr., lived along the once-vital trail that had reverted back to its natural state. Part of the trail would be reopened for the race. Redington was a homesteader with a full kennel. He and his sons were sprint mushers; he used dog teams in salvage operations under contract with the US army.

Redington and Page, with a common goal, united and found helpers. After the death of famous musher Leonhard Seppala on January 28, 1967, the race—officially named the Iditarod Trail Leonhard Seppala Memorial Race but informally known as the Centennial Race—was scheduled to be held on February 11 and 12 of that year. Seppala's widow, Connie, was invited as a guest of honor, flown to Alaska by radio station KFQD, and hosted by the Aurora Dog Mushers Club.

Isaac Okleasik of Teller crossed the finish line first. Running an 11-dog team, the 46-year-old Iñupiaq musher finished 2 minutes and 13 seconds ahead of Pete Shepherd of Fairbanks to take the $7,000 first-place prize (part of a $25,000 total purse). The *Anchorage Daily News* reported on his training: "Okleasik is a working musher who puts in an average of 600 miles a month."

In May 1967, the local press reported that the race organizers were not done yet. A branch of the Wasilla-Knik Centennial Committee incorporated as "Iditarod Trail-Knik Frontiers," which was chaired by Joe Redington and included Dorothy and Von Page and many others, including the media, educators, scientists, salespeople, and Bush pilots. Their goal was the "restoration of the ghost town of Knik and the historic Iditarod Trail" and the establishment of an annual Iditarod Trail Sled Dog Race.

Mushing did not die when the All Alaska Sweepstakes expired. In the decades that followed, villagers in Alaska's Bush kept dogs to run traplines and to pack wood and water. In the Bush and in the cities, mushers ran in derby races large and small as the center of sprint racing shifted toward Fairbanks. For this early 1961 photograph, Gale Van Diest stopped to take a picture of his five-dog working team resting at a shelter cabin about halfway to Holikachuk from the Yukon River. "We were headed to where we were cutting logs to float down the river in the spring for the new village of Grayling," he remembered. "There were no [snow] machines in the country at that time." (Gale Van Diest.)

Starting in 1946, the World Championship Sled Dog Race has been a highlight of Anchorage's popular winter carnival, the Fur Rendezvous (aka Rondy). Traditionally, the multiday races started in downtown Anchorage and ran through the city's trail system. Rondy, the social event of the season, is held in February—the time of year when trappers usually came into town to sell furs. Other attractions include carnival rides, the fur auction, and an Eskimo blanket toss. (NicePictures.)

Before World War II, several mid-distance races between remote villages in the Alaska Interior challenged mushers in the sweepstakes style of multiday racing. In postwar Fairbanks of 1946, the Open North American Championship Races attracted sprint mushers from the Bush, the Railbelt region, and along the highway. The Alaska Dog Mushers Association organized in 1948 to promote both the races and the humane treatment of dogs. (NicePictures.)

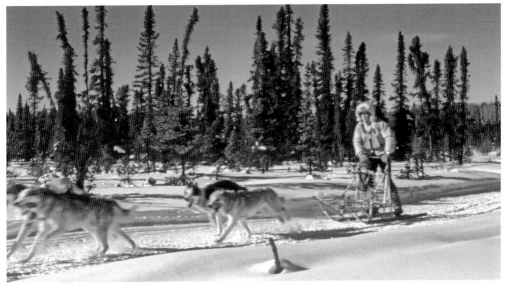

Mushers were sports celebrities in Alaska, western Canada, and the states in the Northeast. Dr. Roland "Doc" Lombard, pictured here in 1974, was a veterinarian from Wayland, Massachusetts, who was popular on the Alaskan race circuit. Lombard won his first North American Championship in 1958—becoming the first non-Alaskan to win—and went on to capture the title five more times. He won the Fur Rendezvous World Championship Sled Dog Race eight times and the Alaska State Championship five times. At age 55, Lombard finished 11th in the 1967 Centennial Race. (Al Hershberger.)

The sprint circuit included an integrated mix of Alaska Native and non-Native men. George Attla (right) was a crowd favorite; fans could easily recognize him due to his unique kicking style on the runners. Attla suffered from polio as a boy, and one knee had been fused. An inspiration to many, he won four Alaska State Championship Races, eight North Americans, and a record ten World Championship titles. In this 1983 photograph from the Alaska State Championship Race, Attla speaks with fellow competitor Charlie Champaine. (Clark Fair.)

Wasilla community booster and history-lover Dorothy G. Page floated her race idea past many mushers but did not find support until she connected with Joe Redington Sr. at the Willow Carnival dog races in 1966. Redington was troubled by how snow machines and airplanes were replacing dogs in the villages, so his hope to rally support for Alaska huskies fit well with Page's plan. Page later wrote of the inaugural 1967 race, "Seppala was picked to represent all mushers . . . but it could just as easily have been named after Scotty Allan." (Jeff Schultz.)

In an ingenious scheme to attract attention to the Centennial Race and the Iditarod Trail while raising money for the purse, Joe Redington Sr. and his wife, Vi, donated an acre of land—"the Centennial Acre"—to be divided and sold in one-square-foot parcels. Each buyer sent $2 and received a deed with title to the land plus a certificate. This raised about $12,000. The committee also sent title to a square foot of Alaska land to the governors of every state, and Dorothy Page forwarded their delighted thank-you letters to Juneau. Another funding outlet nearly failed when the chief of Tyonek, a close friend of the Redingtons, died in a fire before transferring his promised $15,000. Redington was able to talk tribal leaders into loaning him the money by using his own homestead as collateral. (Jeff Schultz.)

In March 1966, after receiving the support of the Aurora Dog Mushers Club, Dorothy Page put the plan in writing and sent it to the Alaska Centennial Commission for approval. Page wrote: "Joe [Redington Sr.] is also interested in helping with the re-opening of the Iditarod Trail as far as Susitna Station and feels it should be kept open as a memorial to the many old timers who mushed this historic route into the interior of Alaska." (Alaska State Library.)

Wasilla, Alaska
March 20, 1966

Herb Adams
Executive Director
Alaska Centennial Commission
Box 1967
Juneau, Alaska

Dear Herb:

At the March meeting of the Aurora Dog Mushers Club, members voted to join the Wasilla Centennial Committee in planning a rather spectacular championship race for centennial year.

Joe Redington Sr. is chairman of the committee. The race will begin at Knik, and the first few miles of the race will be over the historic Iditarod trail. Then the mushers will turn off the Iditarod trail to finish on Big Lake. We will have official timekeepers at Knik and also at Big Lake.

Joe Redington is very enthused about the prospects of making this one of the biggest and most profitable races ever held in Alaska. Joe has "mushed" this trail many times and feels it will make an excellent racing trail.

Joe is also interested in helping with the re-opening of the Iditarod Trail as far as Susitna Station and feels it should be kept open as a memorial to the many old timers who mushed this historic route into the interior of Alaska.

We hope our plans for a sled dog race covering a portion of the Iditarod Trail meet with your approval. As soon as a date is set for the race we would like to have it entered as one of the events for centennial year.

Sincerely yours,

Mrs. Dorothy Page
Chairman
Wasilla Centennial Committee

"NORTH TO THE FUTURE!"

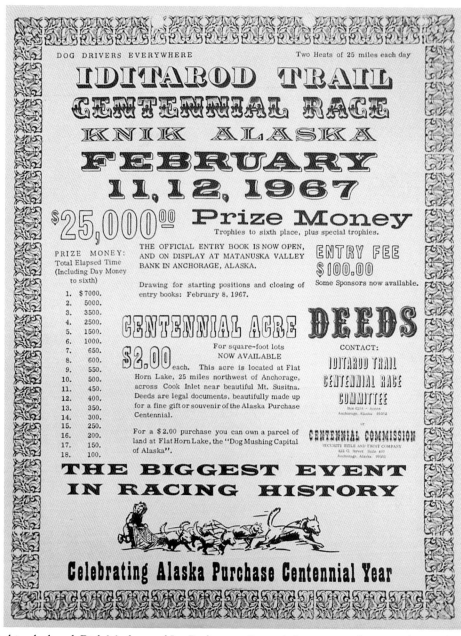

DOG DRIVERS EVERYWHERE Two Heats of 25 miles each day

IDITAROD TRAIL CENTENNIAL RACE
KNIK ALASKA
FEBRUARY 11, 12, 1967

$25,000.00 Prize Money
Trophies to sixth place, plus special trophies.

PRIZE MONEY:
Total Elapsed Time
(Including Day Money
to sixth)

THE OFFICIAL ENTRY BOOK IS NOW OPEN,
AND ON DISPLAY AT MATANUSKA VALLEY
BANK IN ANCHORAGE, ALASKA.

ENTRY FEE
$100.00
Some Sponsors now available.

1. $7000.
2. 5000.
3. 3500.
4. 2500.
5. 1500.
6. 1000.
7. 650.
8. 600.
9. 550.
10. 500.
11. 450.
12. 400.
13. 350.
14. 300.
15. 250.
16. 200.
17. 150.
18. 100.

Drawing for starting positions and closing of
entry books: February 8, 1967.

CENTENNIAL ACRE DEEDS
$2.00

For square-foot lots
NOW AVAILABLE
each. This acre is located at Flat
Horn Lake, 25 miles northwest of Anchorage,
across Cook Inlet near beautiful Mt. Susitna.
Deeds are legal documents, beautifully made up
for a fine gift or souvenir of the Alaska Purchase
Centennial.

For a $2.00 purchase you can own a parcel of
land at Flat Horn Lake, the "Dog Mushing Capital
of Alaska".

CONTACT:

IDITAROD TRAIL CENTENNIAL RACE COMMITTEE
Box 1234 – Annex
Anchorage, Alaska 99501
or
CENTENNIAL COMMISSION
SECURITY TITLE AND TRUST COMPANY
425 G. Street Suite 400
Anchorage, Alaska 99501

THE BIGGEST EVENT IN RACING HISTORY

Celebrating Alaska Purchase Centennial Year

Working by hand, Dick Mackey and Joe Redington Sr. used chainsaws and axes to clear and mark nine miles of the Iditarod Trail for the race. The race route was set to include that portion of the old trail and planned to be held in two heats covering 50 miles between Knik and Big Lake. Businesses along the route were happy for the influx of people, and entrants and spectators alike declared the race a success. As for Redington, who had no time to train, he counted on his sons to cobble together a team. "They really fixed me up," he later said, claiming they gave him the "culls and cripples" pulled out of their own teams. "The dogs I ran, I hadn't even seen them," he joked. Participants wanted another race, but it would not happen again until 1969. (Alaska State Library.)

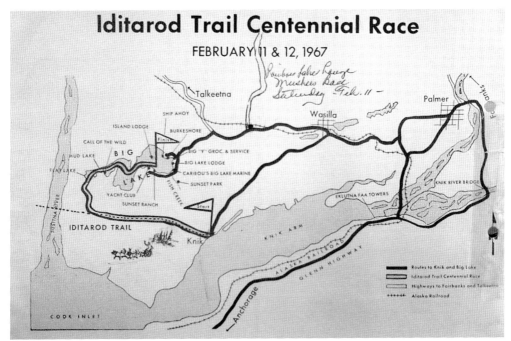

Iditarod Trail Centennial Race

FEBRUARY 11 & 12, 1967

Race cofounder Joe Redington Sr. finished 47th out of the 58 mushers who competed in two heats of 25 miles, while his son Joee, winner of the 1966 World Championship Sled Dog Race, finished 12th. Afterward, Joe Redington Sr. told a reporter: "This is the Iditarod Trail Race, and I think we have a course that honors the trail. It's a man punisher and a dog pounder, but these mushers like it and that's the test of any trail." (Alaska State Library.)

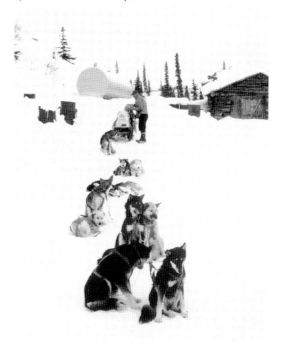

In 1967, 50 years after the last All Alaska Sweepstakes, Isaac Okleasik of Teller won the Iditarod Trail Leonhard Seppala Memorial Race, which honored a fellow man from the Seward Peninsula. Two men from Huslia, George Attla (the "Huslia Hustler") and Werner Vent, took fifth and seventh place, respectively, in the Centennial Race. Four Fairbanks entrants confessed to running a grudge race among themselves, although all four placed in the top 10. At the end of the race, the top finishers were asked if they'd like to see more Iditarod Trail races, and they gave a resounding yes, adding "preferably with the same purse." In the 1973 image at right, Okleasik is preparing to leave Rainy Pass during the first 1,000-mile Iditarod race. (Dan Seavey Collection.)

IDITAROD TRAIL
COMMITTEE

KNIK ALASKA

BOX 6108 ANNEX
ANCHORAGE • ALASKA

Members of the Iditarod Trail Committee created this letterhead to use for correspondence and race promotion. A month after the race, in March 1967, Wasilla-Knik Centennial Committee chairwoman Dorothy Page sent a glowing report to Herb Adams, the executive director of the Alaska State Centennial Commission, in Juneau: "Our centennial year race proved to be the biggest—58 top mushers entered—and the richest—$25,000—in the history of the sport of sled dog racing in Alaska, or for that matter, anyplace! It was the best thing that happened to dog mushing in many years. The prize money offered finally put an Alaskan sport somewhere near other sports in the competitive field. Prize money offered for other sports in the smaller states has always been big. Here in Alaska, the largest state, where we do not have football, baseball, boxing, golf, or other well-paying sporting events, sled dog racing has never been up in the top bracket, moneywise. Our Iditarod Trail Centennial race finally broke the ice." (Alaska State Library.)

4

1973: Birth of the Last Great Race

The best ideas are produced during brainstorming sessions, when many people simultaneously kick around their thoughts. This was the case as the Iditarod began to take shape. In the era before social media helped ideas to go viral, Joe Redington Sr. was at the center of the network, and he became a carrier of who was saying what. He lived in Knik but spent summers working in Alaska's northwestern fishing industry. A natural-born encourager, Redington also had the jaws of a pit bull when it came to latching on to an idea, and he breathed hope.

Among his Nome mushing friends and back in his home valley, Redington lit idea fires in the hearts of those like Dick Mackey, Howard Farley, Gleo Huyck, Tom Johnson, Joe Delia, Dave Olson, Leo Rasmussen, Ed Carney, Al Hibbard, Carl Glavinovich, and Dennis Corrington. Spouses, friends, and friends of friends were drafted in the friendliest way. "We're doing this. Do you want to join us?" As Farley and Mackey remember, Redington was the man who would tell a friend how good he or she would be at a specific task, then ask: "How about it?" As Redington reached out to his network, Dorothy Page and her husband, Von, also widened the net by sending letters, making phone calls, and hosting meetings in their Lake Lucille home.

At Wasilla's Kashim Inn, the organizing committee downed hot Tang and coffee as they planned and set down rules (some of which were resurrected from the All Alaska Sweepstakes) and discussed who else to contact. Redington wanted a $50,000 purse and approached all possible funding sources, including Maj. Marvin "Muktuk" Marston, who personally donated $10,000.

On Saturday, March 3, 1973, the first musher left Tudor Track in Anchorage in front of a crowd composed of friends and family but few outside the mushing realm. That first year, the race had an all-Alaskan, all-male slate. Mackey remembered that some wives were crying as they wondered, really, if their husbands would live through it. The mushers planned for a long, strategic camping trip, but nobody really knew if it would work. For all intents and purposes, everybody was a rookie.

Nearly three weeks later, Dick Wilmarth, a miner from Red Devil, Alaska, crossed the finish line in Nome—the first of 22 mushers to finish—and took home the $12,000 first-place prize.

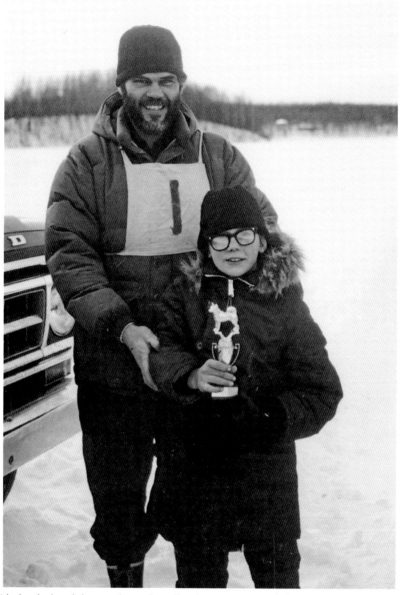

In 1972, Alaska declared dog mushing the official state sport, and the Anchorage-area Aurora Dog Mushers Club sponsored a children's race to encourage the younger generation to jump on the runners. Musher Tom Johnson was a local English teacher who loved the sport. Early race organizers credit Johnson and fellow teacher/musher Gleo Huyck with boosting enthusiasm for the inaugural Iditarod when others were about to give up. The two men made the race launch a priority and infused the weary with energy. Here, Johnson (wearing Bib No. 1) stands with a young Mitch Seavey, who is proudly holding his trophy. Mitch, the son of Dan Seavey, who ran in the first of many Iditarods, grew up to become a two-time champion of the race and watched his own son Dallas—the youngest musher ever to win the Iditarod—claim victory in 2012. (Dan Seavey Collection.)

1973: BIRTH OF THE LAST GREAT RACE

Anchorage musher Dick Tozier, a well-respected official in sprint-mushing events, made a trusted judge for the new distance race. In 1976, he looked back at changes in dogs and performance during his career, saying, "Many of the local mushers ran registered Siberian huskies, and most of us had bigger dogs . . . Then some of the Native teams started coming in from the villages and cleaning house . . . As you might guess, we drew the logical conclusion and turned to breeding smaller dogs." (Jeff Schultz.)

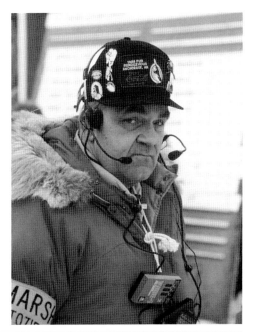

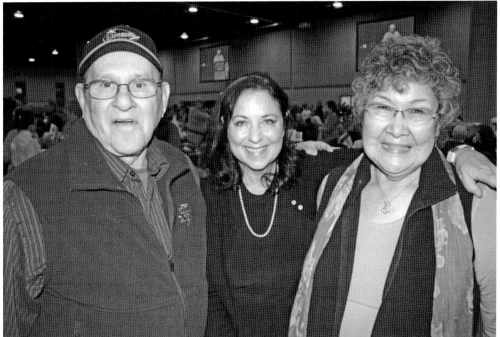

Three old friends gathered at the 2013 Mushers Banquet in Anchorage. Iditarod's first employee was Raine Hall (center), who edited the magazine *Iditarod Runner* and managed the office in Wasilla, which, in 1978, was attic space above Teeland's Country Store rented for $1 per year. Hall stands between Howard and Julie Farley of Nome, who helped shape the race in 1972 and 1973. Joe Redington Sr. encouraged Howard to volunteer as well as run the race; meanwhile, Julie enlisted volunteers and set up Iditarod headquarters for the north end of the race.

Former Nome mayor Leo Rasmussen, like others who helped start the Iditarod, wore many hats through the years, serving as a fundraiser, race official, event organizer, and community booster. He also initiated the Trail Mail program—each musher is required to carry a bundle of mail from Anchorage to Nome in a salute to the mail carriers of Iditarod's past. At the finish line, a race official goes over a checklist of required items in each finisher's sled, and Trail Mail is on the list.

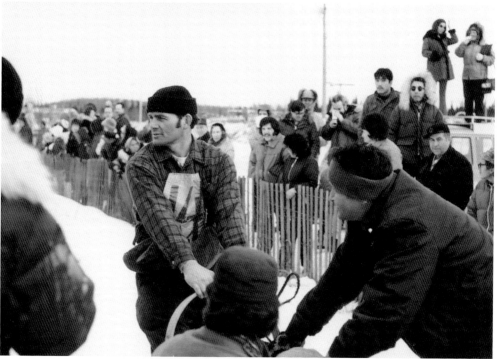

Musher No. 14, Dan Seavey, and his team of 11 dogs await the countdown at the 1973 starting line at Anchorage's Tudor Track (now known as the Tozier Track). Seavey came to Alaska in 1963 and was part of the original core of organizers when the race was coming into focus. While he led the way for much of the first race, clearing trail for those behind him, Seavey finished in 3rd place; in 1974, he claimed 5th. Seavey's love of mushing has been passed down through his family, and Seavey men are among the most competitive mushers in race history. Today, the Seavey family operates an attraction in Seward—Ididaride Sled Dog Tours—that offers tourists a taste of the thrill of mushing. (Dan Seavey Collection.)

Herb Foster of Kotzebue pauses to "snack" his dogs on the way to Rainy Pass in 1973. Regionally, some mushers had an advantage over others. Men from the treeless regions of northwestern Alaska were right at home when the route brought them to the coast, but in the dense trees and damp, heavy snows of the Alaska Range, it was a different world. (Dan Seavey Collection.)

George Attla prepares to leave Bear Creek Mine during the inaugural race. Mushers who had established themselves in sprint races jumped on board with the Iditarod from the start but were surprised by tags such as "sprint" or "distance" musher. It was all just mushing, remembers musher Bill Cotter. Attla was a superstar in the sprint arena; a movie about his life, *Spirit of the Wind*, was released in 1979. (Dan Seavey Collection.)

John Coffin, an Iñupiaq Eskimo man from Noorvik, was traveling with Dan Seavey in the 1973 race when they stopped for a break south of Poorman. Ahead, the trail led to the village of Ruby on the Yukon River. Judging from Coffin's open parka, the day was warm. Dozens of creeks in the Ruby-Poorman District had been mined decades earlier, but in 1998, the largest nugget ever found—294.1 troy ounces—was discovered at nearby Swift Creek. (Dan Seavey Collection.)

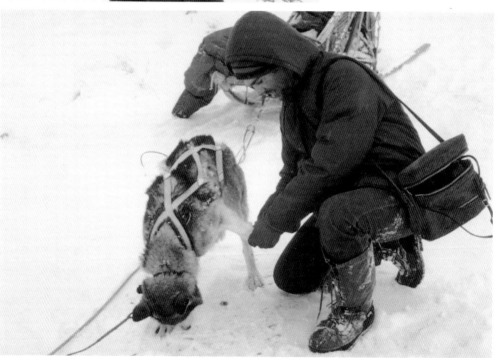

Dr. Terry Adkins, a US air force veterinarian, was approached by Joe Redington Sr. before the 1973 race and asked if he would he be willing to look after the dogs. Adkins requested the time off, but his superior officer gave a resounding "no." Redington went into action, speaking with his high-ranking military friends (he worked as a salvage musher at the local Army base). The Army talked to the Air Force, and Adkins was released to work on the trail for an indeterminate time. Adkins was the sole Iditarod veterinarian in 1973; he ran the race himself in 1974. (Dan Seavey Collection.)

1973: BIRTH OF THE LAST GREAT RACE

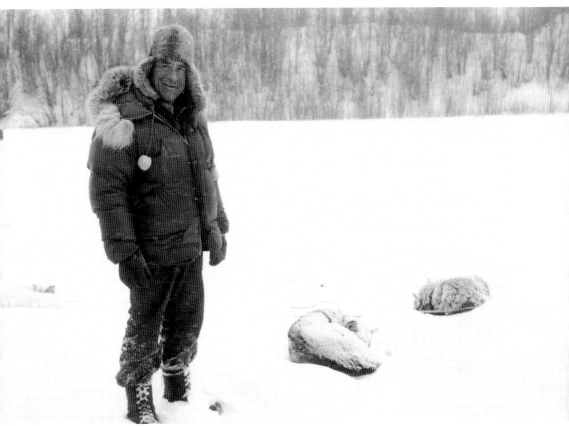

In 1973, Bobby Vent knew the rules well enough to bend them. He hired a private snow-machine driver to break trail ahead of him and carry all but a few pieces of gear in his sled, as required by race rules. George Attla borrowed Vent's idea and also paid for the extra help of a snow-machiner that year. For 1974, the committee rewrote the race rules to be more specific about not allowing outside assistance. Vent is pictured here at White Mountain. (Dan Seavey Collection.)

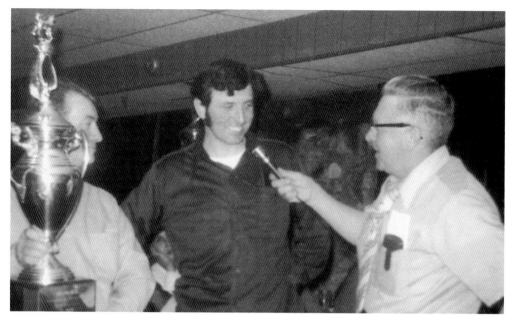

At the first finisher's banquet, Joe Redington Sr. (left) prepared to present the trophy to champion Dick Wilmarth (center) while Orville Lake, a musher covering the race for Anchorage radio station KYAK, manned the microphone. Wilmarth, a miner from Red Devil, Alaska, was the first of 22 mushers to finish. He crossed the finish line in 20 days, 49 minutes, and 41 seconds, and received $12,000 in prize money. Redington was busy taking care of loose ends in the first Iditarod and did not even get to race. In 1974, however, he ran and placed 11th. (Dan Seavey Collection.)

Dick Wilmarth (left), Bobby Vent (center), and Dan Seavey jokingly peer down the trail as they await the arrival of George Attla at the 1973 finish line. Along the trail, Wilmarth had been unable to find any of the food and supplies that he had shipped out ahead of time and had to rely on others to help feed himself and his dogs. He was desperate for dog food in Kaltag when Bush pilot Bob Vanderpool flew in a few beaver carcasses. Rod Perry, musher and author of *Trailbreakers: Pioneering Alaska's Iditarod*, wrote that, "On arriving in Nome the winner, [Wilmarth] would at last find [his supplies]—all in one heap in Munson's Hangar." (Dan Seavey Collection)

THE FIRST SATURDAY IN MARCH

Those in Anchorage for the Iditarod start can feel the difference in the air—it is supercharged with the anticipation of witnessing history. Downtown sidewalks are packed with people shuffling through the crowd. Experts chat over loudspeakers, then start another countdown. A roar of approval and mittened applause resound as a team slides by. The shrieks of pent-up dogs in the staging areas bounce off the buildings. At the corner of Fourth and D Streets, a bronze racing dog is often mistaken for Togo or Balto, dogs who participated in the historic serum run of 1925—it is actually dedicated to participants in both the World Championship Sled Dog Race and the Iditarod, for the corner marks the start line for both great races.

The Iditarod has matured from a grassroots effort to a major undertaking that attracts competitors from around the world. The top-tier men and women are not in it for wilderness camping with the dogs, as Mary Shields was in 1974. And they are not lumbering in with a 100-pound sled, as Dick Mackey did in 1973. Competitors have broken the 11-day barrier, then the 10-day, and some teams now run the race in less than 9 days. Mushers are not forcing the dogs to run until they are spent; the case is just the opposite—with advances in care, nutrition, and breeding, these are the best times for dogs. Foot care, the bane of early competitors, is now a manageable issue. Careful calculation of the ideal ratio of a run/rest schedule makes for happy, efficient pups. Gear is lighter, clothing is warmer and more comfortable, and when Jeff King invented a sit-down sled, it was immediately copied.

Today, it takes fewer days to run the Iditarod, but it is still one of the most grueling races on the planet. Teams travel in breathtakingly cold temperatures and through challenging storms that dogs handle better than their suited-up mushers do. Sleep deprivation undermines mental aptitude, and during media interviews at checkpoints, when mushers are asked about strategy or forecasting or even just how their dogs are doing, sometimes the answer is a simple "uhhhh."

The Iditarod has produced great people worth emulating and dogs worth writing books about, much like during the days of the All Alaska Sweepstakes.

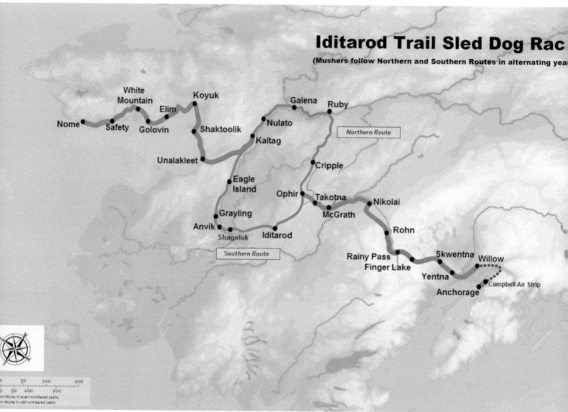

Iditarod Trail Sled Dog Rac

(Mushers follow Northern and Southern Routes in alternating yea

White Mountain
Koyuk
Elim
Nome
Safety
Golovin
Shaktoolik
Nulato
Galena
Ruby
Kaltag
Unalakleet
Cripple
Eagle Island
Ophir
Takotna
Nikolai
Grayling
McGrath
Anvik
Rohn
Shageluk
Iditarod
Rainy Pass
Skwentna
Willow
Finger Lake
Yentna
Campbell Air Strip
Anchorage

Northern Route

Southern Route

The Iditarod Trail Sled Dog Race begins in Anchorage on the first Saturday of March with a ceremonial downtown start and follows the city's trails to Campbell Airstrip; at that point, the dogs are done for the day. On Sunday, dog trucks roll onto frozen Willow Lake, and there, at the restart, official timekeeping begins. Hundreds of fans line the orange fencing along the starting chute as loudspeakers introduce mushers and sponsors, one by one, followed by a countdown. At last, the dogs are released and streak toward the open trail, with fans standing so close that mushers can high-five them as they pass. Later, after the teams cross the Susitna River drainage, they will pass through several different microclimates, traversing mountain ranges and following frozen rivers, as they head for the windy Bering Sea coast. Beyond Norton Sound, more challenging elevation changes await until the dogs at last lope into Nome.

Richard Burmeister designed a belt buckle for the Nome Kennel Club to award to every Iditarod finisher. They were first distributed at the 1975 Nome Awards Banquet; the club then retroactively gave buckles to those who finished in 1973 and 1974. Numbered editions designed by various artists also have been offered to fans as collectibles.

In the early years of the Iditarod, a pilot named Larry Thompson was the kingpin in a small cadre of pilots who donated time, planes, and sweat to fly people, dogs, and supplies to where they belonged. While Thompson was the sole pilot at first, the Iditarod Air Force has since grown to include more than two dozen men and women. Here, 2009 volunteer chief pilot John Norris prepares to stuff hay bales into his plane headed for Rainy Pass. While most checkpoints receive straw for the dogs to rest upon, a small herd of summer packhorses lives at the Rainy Pass Lodge, so the lodge sends hay instead of straw. (Jeff Schultz.)

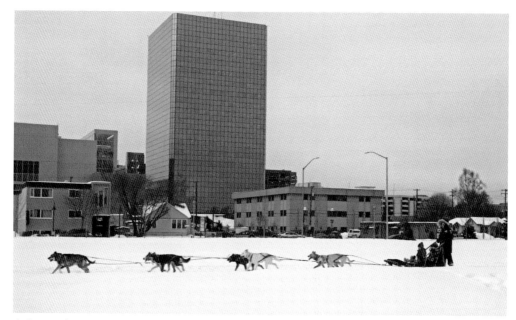

A dog-mushing concession on Anchorage's downtown Park Strip allows urban dwellers to experience a ride in a dogsled. Iditarod follows on the heels of the annual winter carnival, Fur Rendezvous, which features sprint-racing action with its World Championship, as well as Alaska Native art and photograph displays, carnival rides, a hockey tournament, footraces, and a fur auction.

Alaska's favorite balladeer is "Hobo Jim" Varsos, whose Iditarod theme song fans know by heart. Here, he entertains during the Mushers' Drawing Banquet at Dena'ina Civic and Convention Center in downtown Anchorage, leading the crowd in his famous chorus, "I did, I did, I did the Iditarod Trail!" With about 2,000 people in attendance, mushers and other VIPs scattered at tables throughout the banquet hall spend time signing programs and posters for fans who work the room looking for their favorites. After dinner, each musher will walk up on stage, pull a number out of a fur mukluk (boot), thank their sponsors, and say a few words to the audience. The number pulled out of the mukluk will determine the musher's starting position on Saturday morning.

Sometimes the ceremonial start in Anchorage is a "see and be seen" affair—many Alaskans break out their fancy parkas, hats, and fur mitts for the occasion.

Below, Vern Halter leaves the 1999 Iditarod start in downtown Anchorage. The perennial Iditarod musher took third place that year, his best showing ever, completing the race in 10 days, 6 hours, 25 minutes, and 40 seconds. Except for one year, Halter ran a 1,000-mile event every year between 1983 and 2005, focusing on either the Iditarod or the Yukon Quest International Sled Dog Race. After running the Iditarod in the 1980s, he switched to the Yukon Quest in 1989, finishing second that year and winning in 1990. He invites visitors to tour his Dream a Dream Dog Farm in Willow. (Jeff Schultz.)

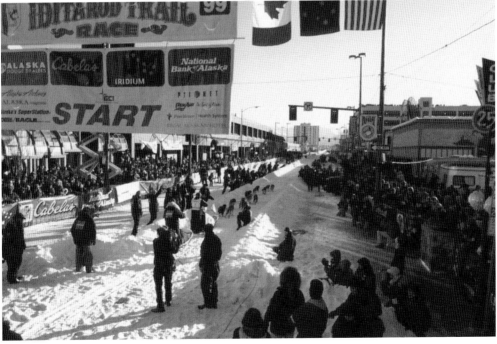

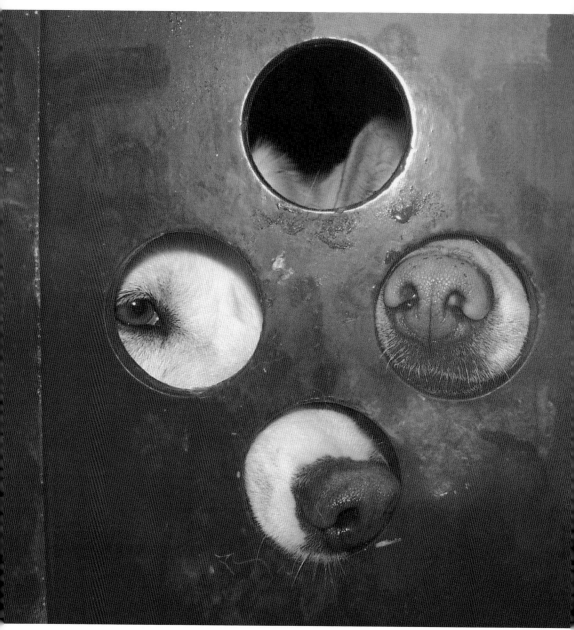

The "dog boxes" often seen on atop "dog trucks" make for small quarters, but offer security and protection as mushers travel. These two dogs, photographed at the 2003 Iditarod start, attempt to soak up the sights and smells of what is happening outside the box. As the start time draws closer, mushers tether, or "peg," the dogs on short lengths of chain attached to their trucks. The dogs can then relieve themselves, stretch their legs, and visit with other dogs before it is time to line out in front of the sled. (Barbara Lake.)

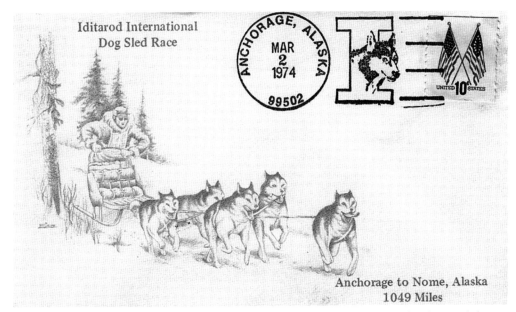

Iditarod International
Dog Sled Race

ANCHORAGE, ALASKA
MAR
2
1974
99502

UNITED 10¢ STATES

Anchorage to Nome, Alaska
1049 Miles

The Trail Mail program, linked to the Iditarod race from the start, honors the dogs and drivers who carried mail on the Iditarod Trail. In the staging area behind the start line, volunteers give each musher a small packet of envelopes—a required item in the sled bag—to sign and slip into their sleds. Each year, the bundle has a new design. The mail is postmarked in Anchorage and given to officials after the musher crosses the finish line; it will be postmarked again in Nome, making each letter a rare collectible item. This one is from the 1974 race.

The late Carl Huntington of Galena holds the record for winning both the World Championship Sled Dog Race (the sprint race held during Anchorage's Fur Rendezvous) and, in 1974, the Iditarod. His record stands unbroken. "People believe the distance dogs are really good for distance; the sprint dogs good for sprint," fellow sprint champion George Attla told the *Anchorage Daily News* after Huntington's death in 2000. "He proved it wasn't so." (Jeff Schultz.)

Artist Jon Van Zyle ran the Iditarod himself in 1976 and designed the first Iditarod poster the following year (pictured at left—the original is in color). He was named "Official Artist of the Iditarod" in 1979. Every year since 1977, Van Zyle has created new art for posters and donated all proceeds generated by their sales back to Iditarod. He ran the race again in 1979 and was inducted into the Iditarod Hall of Fame in 2004. (Jon Van Zyle.)

A serious competitor and a friend to all, Herbie Nayokpuk was in the first year's race and finished 10 of the 11 times he entered between 1973 and 1988. Nayokpuk placed in the top 10 each of those years except two, earning him the nickname "The Shishmaref Cannonball," combining the name of his Iñupiat village with the projectile he seemed to be when he raced. Rarely seen without a smile on his face, Nayokpuk was also a brilliant trainer who believed that the dogs needed playtime, too, even if there was a race in progress. In 1979, he acquired a major sponsor—Chevron—and happily sported their logo on his sled. (Chuck and Shirley Newberg.)

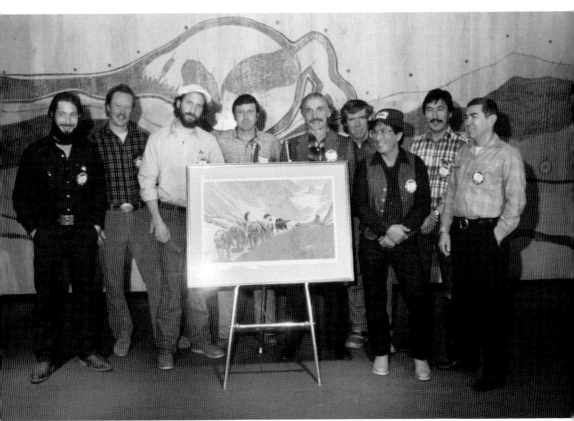

Over the years, the Iditarod Trail Committee has developed many creative ideas for fundraising. In 1983, an assembly of mushing greats gathered at the Anchorage Sheraton Hotel to sign copies of a print, titled "Reaching the Pass," by renowned Alaskan artist Fred Machetanz. Each person signed 1,049 copies of a limited-edition print and posed for a photograph when they had finished. Pictured here are, from left to right, Rick Mackey, Rick Swenson, Dean Osmar, Dick Wilmarth, Dick Mackey, Joe May, Emmitt Peters, Carl Huntington, and Jerry Riley. (Jeff Schultz.)

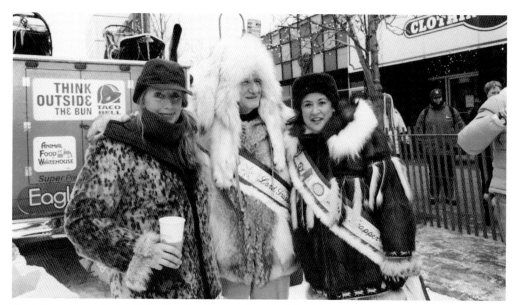

On Iditarod race day in 2008, Fur Rendezvous "royalty" Lord Trapper Ken Stout and Lady Trapper Maria Downey buddied up with 1985 Iditarod champion Libby Riddles (left). While Stout was involved in local politics for years, on race day he was best known as the father of musher DeeDee Jonrowe. Downey was an anchor on KTUU, Anchorage's NBC affiliate. Riddles was the first woman to win the Iditarod. (Theresa Daily.)

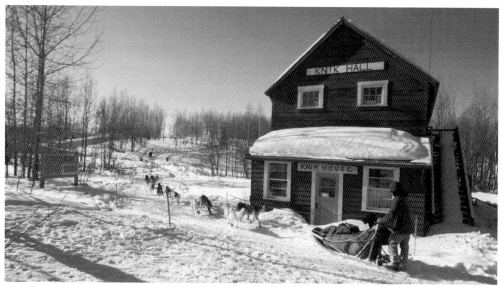

In this image from the 1995 Iditarod, musher John Barron passes in front of Knik Museum and Mushers' Hall of Fame at Knik. The old structure, which once served as a pool hall, is now the home of the Wasilla-Knik Historical Society and houses many important artifacts. In the years when Dorothy Page was in sway, she and the Iditarod Trail-Knik Frontiers group dreamed of finding funds to create a living history park in Old Knik. While part of her group's vision was successful—establishing the annual race—the revival of Knik never came to pass. (Jeff Schultz.)

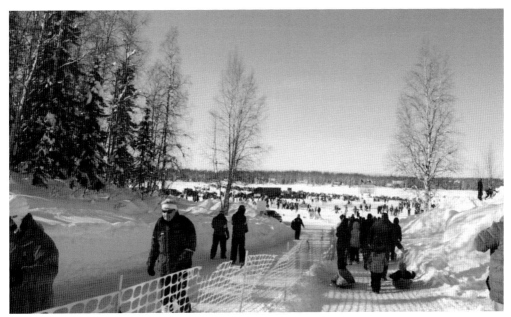

On the first Saturday of March, the ceremonial start is in downtown Anchorage, but the clock does not start ticking until Sunday, when mushers depart the restart. Traditionally, Wasilla was home to the restart, and the race route passed through Knik before advancing to Yentna. However, in 2008, after several years of hit-and-miss snow cover at Wasilla, the official restart location was permanently changed to Willow, accessible by road on the Parks Highway and always sure to be snowy. Fans follow a wide trail down to the lake, where the mushers leave the starting chute.

Air Force major (Dr.) Thomas Knolmayer, pictured leaving the 2005 Willow restart, was the only active-duty contender in that year's race. Members of the military have been part of the Iditarod since its inception. The military was essential to getting the race off the ground in 1973, with their donated labor and equipment for trailbreakers arriving in Nome by snow machine—after a grueling trip—just minutes before first-place winner Dick Wilmarth crossed the finish line. In 1973, Iditarod's first and, that year, only veterinarian was Dr. Terry Adkins, an Air Force officer. When Adkins entered the race the following year, he solicited help from Army veterinarian Dr. Jack Morris, who served as the sole veterinarian in 1974. (Tech. Sgt. Keith Brown.)

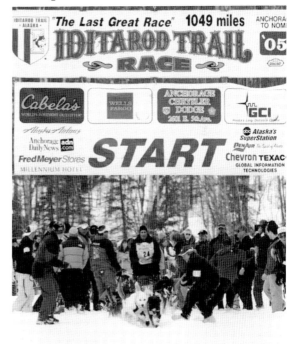

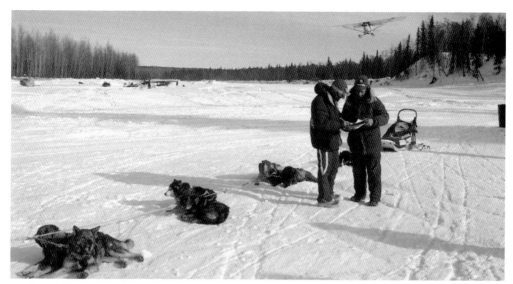

In this 1987 image, Skwentna resident Joe Delia (left) checks in Gordon Brinker at the Delia cabin near the confluence of the Yentna and Skwentna Rivers. Joe and his wife, Norma, were involved in Iditarod from the day Joe was out checking his traps and ran into a skier who was seeking to reblaze the Iditarod Trail for the race. "It startled both of them," Norma said. The man led Joe Delia back to Joe Redington's camp, and they agreed that they would rendezvous the next day. Snow prevented the meeting, but Redington and Dick Mackey flew back to Skwentna and welcomed help from Delia, ultimately incorporating part of his trapline trail into the race route. (Jeff Schultz.)

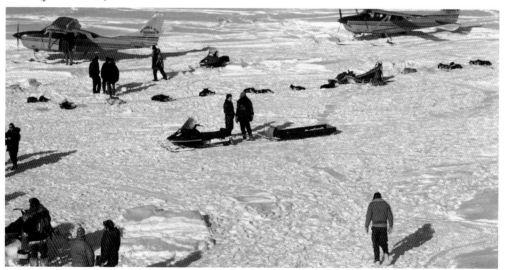

Sled dog teams and volunteers mob the Skwentna checkpoint in this 1985 photograph. The Delias hosted the Skwentna checkpoint for decades, checking in mushers and feeding (out of pocket) a steady stream of mushers, volunteers, and media members with the help of their friends, a volunteer posse known as the "Skwentna Sweeties." The crowds were sometimes so large that meals in the Delias' 24-by-32-foot cabin were standing-room only. (Jeff Schultz.)

While volunteering in the 2007 race, checker Jim Gallea, housed in a warm-up wall tent at the Nicolai checkpoint, sends a radio message to the "comms," or communications volunteers, a few hundred yards from his place at the musher check-in area. He relays the musher's arrival times, which will be entered in the computer and made part of the official record. Early communication during the race was accomplished with satellite phones and a network of ham radio operators who were stationed along the trail, relaying messages back and forth. (Jeff Schultz.)

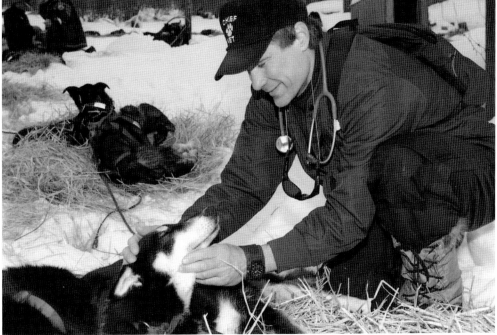

Chief veterinarian Stuart Nelson oversees a group of about 50 volunteer veterinarians, most of whom serve at checkpoints along the trail, examining the canine athletes upon arrival. The veterinarians will treat minor issues and advise mushers about anything serious. They also have the authority to pull a dog that is not fit to continue, although the musher has usually already decided on that. Here, Dr. Nelson checks a dog at Takotna during the 2005 race. (Jeff Schultz.)

During the 1976 race, musher Jerry Riley stopped in Nikolai to make sled repairs. Riley placed second in 1975 and 1977, but in 1990, he was at the center of a maelstrom after dropping an injured dog at White Mountain. After failing to notify veterinarians of the dog's extensive injury, Riley was disqualified. After research and consideration of dog deaths on other teams run by Riley, the ITC board voted to ban him. Joe Redington Sr. told reporters, "We wish it hadn't come to this, but I think it had to happen for the good of the Iditarod." Riley was not the only musher to come under scrutiny. Even Susan Butcher and Martin Buser, winners of the race's Leonhard Seppala Humanitarian Award, experienced a dog death from congenital defects not spotted during prerace medical tests. In response to criticism from animal-right groups, the ITC wrote tighter race rules, required prerace screening, increased veterinary corps at every checkpoint, and listed investigative steps to be taken in the rare instance of a death. In 1999, the ITC lifted Riley's ban for one year; he entered and scratched from the 2000 race. (Jeff Schultz.)

THE FIRST SATURDAY IN MARCH

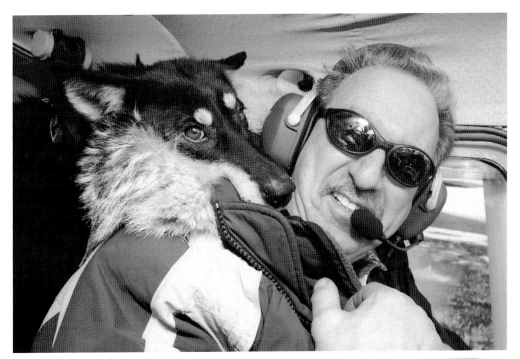

Mushers know if a dog's heart is not in the race anymore. Whether it is from fatigue, sore feet, stomach problems, or lack of fun, a dog that is ready to go home may be "dropped" at certain checkpoints. Dropped dogs are checked out by a vet, then flown to where volunteers care for it until the musher's representative claims it. Here, volunteer pilot Danny Davidson has a friend in Cory, a dropped dog picked up in Takotna. Mushers must finish with the dogs they started with. While they are permitted to drop dogs, they may not add any. (Jeff Schultz.)

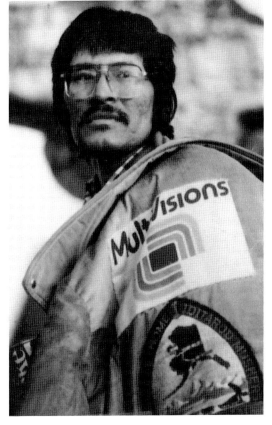

In 1973, Howard Albert of Ruby was 16 and out on the trapline with his siblings and dad when the first Iditarod was run. Inside their tent on the Titna River, they listened intently to the race finish on the radio. Albert entered and placed all four times he ran, twice landing in the top 10. In 1982, Howard's sister Rose ran the Iditarod with his team and finished the race while 10 others scratched. (Rose Albert.)

If the Iditarod miners of 1910 could have peeked into the future, this 1995 scene at the old Iditarod town site would have bewildered them. Bags of dog food, tagged with the checkpoint name and that of the musher, form a line in the snow. The bags are handed out to mushers in advance of the race. Each entrant is responsible for filling the bags with food and supplies, then returning them for transport to points along the trail. (Jeff Schultz.)

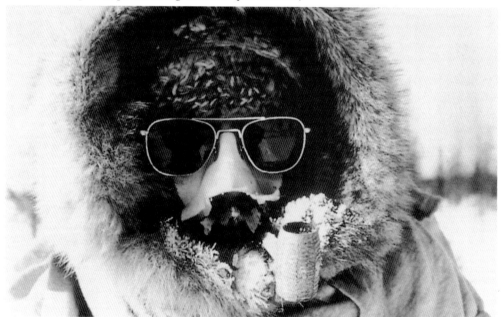

In 1976, Jon Van Zyle and his team were headed for Shaktoolik when he stopped for this picture. "I had on every stitch of clothing I had with me," Van Zyle said. "Even the extra pair of long-johns I had wrapped around my neck didn't help." (Photograph by Dennis Corrington.)

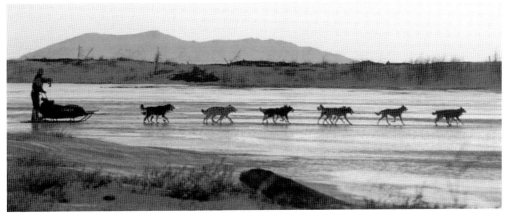

Rick Swenson first entered the race in 1976. Through 2001, minus a scratch in 1996 and a respectable 11th place in 1998, Swenson consistently placed in the top 10, picking up a record five championships in the process. Swenson's record from 2002 onward was less consistent. Swenson motivated others to bring their best race to the start line. He is pictured here at Shaktoolik during the 1989 Iditarod, a year when he took third place. Swenson belongs to the Mush with P.R.I.D.E. (Providing Responsible Information on a Dog's Environment) organization, serves on the Iditarod Board of Directors, and is a longtime member of the Alaska Miners' Association. (Jeff Schultz.)

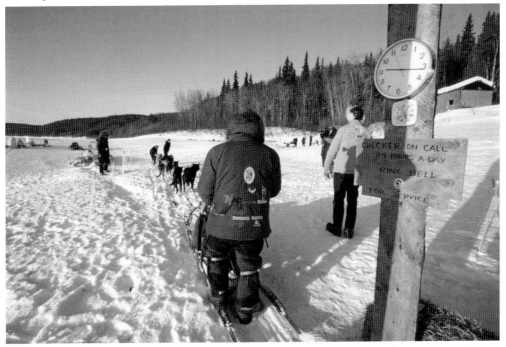

Here, John Baker of Kotzebue arrives at the Eagle Island checkpoint in the 1996 race. Clever checkers installed a buzzer system for incoming mushers in case the checkers had stepped away when a competitor arrived. A perennial entrant, Baker ran his first Iditarod in 1996 and was frequently among the top 10 finishers. In 2011, Baker won the championship, becoming the first Alaska Native musher to claim the title. (Jeff Schultz.)

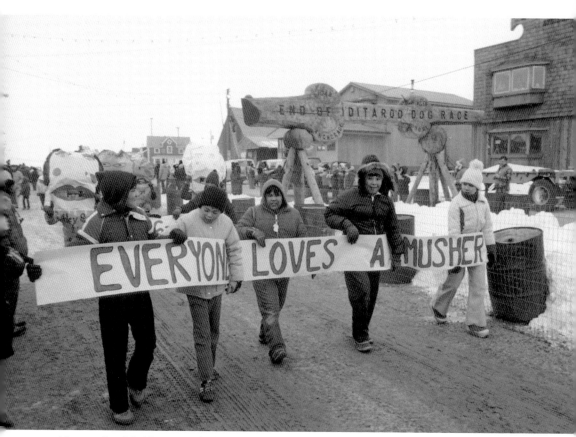

Nome schoolchildren marched through the streets at the 1983 finish in a parade honoring the Iditarod mushers. The Burled Arch finish line is visible behind them. An icon of the Iditarod, the Burled Arch was conceived and created by Red "Fox" Olson, a gold miner from Fox, Alaska, and erected for the 1975 Iditarod. Olson competed and finished last in the 1974 race. Upon his return home, he chose a burled spruce log that he had collected from Rosie Creek (outside of Fairbanks), and got help from the Fairbanks Lions Club to work on splitting, engraving, and finishing the log and support pieces. Altogether, the finished arch weighed two and a half tons. Howard Farley, a principal Iditarod organizer in Nome, solicited funds around town and raised $1,300 to have it air-freighted to Nome. Over time, the elements damaged the original arch; 25 years later, a new one replaced it. The original is now located on an inside wall of the Nome Recreation Center. (Jeff Schultz.)

Thirty minutes after crossing the finish line in 1974, Dan Seavey was revived with a piece of his wife Shirley's famous "trail cake" in Nome. Seavey went on to found the Seward Iditarod Trail Blazers and serve on the ITC's Board of Directors and on the board of the Iditarod Historic Trail Alliance. (Dan Seavey Collection.)

Joe Redington Sr. (left) and Dan Seavey savor the moment at the 1997 finish line. The year marked the 25th anniversary of the Iditarod, and the last time that Redington, then 80, ran the race, finishing in 13 days, 4 hours, 18 minutes, and 57 seconds. In his career, Redington started the Iditarod 19 times and scratched 4 times. He was in the top 10 seven times; four of those in the top five. (Dan Seavey Collection.)

In this image, the 1993 Iditarod Trailbreakers gather under the Burled Arch in Nome. In an ironic twist, the "iron dogs" that Joe Redington Sr. rued for taking over the job of the sled dog were put to good use during the first Iditarod, when a crew of Army soldiers on twin-track Ski-Doos was secured to break trail in advance. On race day, another five civilian snow-machine operators left the start line ahead of the mushers. In Nome, where news of a big race was in the air, some residents were quite shocked when a mixed bag of snow machiners—those who did not break down—motored into town. (Jeff Schultz.)

6

A Thousand Miles
of Hazards

In February and March 1908, a US army detail of five men, the so-called Winter Reconnaissance party, completed its foray by dog team from Seward to Nome and offered a detailed report to the Alaska Road Commission. Col. Walter Goodwin concluded that an 876-mile route from the Kenai Peninsula north and northwest through the Iditarod Mining District and onward to Nome would shave 465 miles off the existing Valdez-to-Nome route and recommended developing the route the party had surveyed. It was first known as the Seward Trail, and later, the Iditarod Trail.

Portions of the route, which had been used for millennia, were absorbed into the official trail, and the main line, along with a smaller network of side trails, was regularly used by gold seekers and dog mushers with freight sleds carrying as much as a half-ton at a time.

With the onset of travel by snow machine and more freight deliveries by airplane, fewer people used the trail system; by the 1960s, it was completely grown over in places. Joe Redington Sr., of Knik (which lies along the historic trail), solicited civilian and military volunteers to clear and reopen a portion of the route for the 1967 Centennial Race and worked for another decade to gain federal recognition; he was supported by Alaska's congressional delegation. In 1978, the Iditarod Trail was finally designated a National Historic Trail, one of the first four in the United States.

IDITAROD TRAIL SHELTER CABINS

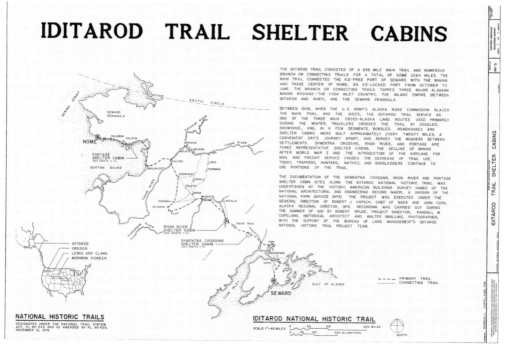

Joe Redington Sr. and others began stumping to resurrect the historic Iditarod Trail as early as the 1950s. A decade later, they received permission to clear a portion for the Centennial Race and were then allowed to clear more in preparation for the first Iditarod. Redington enlisted the help of Alaska's congressional delegation to gain support for a National Historic Trail. (LC.)

The Iditarod Trail shelter cabin called Old Woman, pictured here in 1912, was once a point along the communications corridor for the Washington-Alaska Military Cable and Telegraph System (WAMCATS), constructed by the US Army Signal Corps in 1900 to link Seattle with points across Alaska. By 1904, the Signal Corps had laid about 2,100 miles of undersea cable, more than 1,400 miles of landlines, and a short wireless segment. Other Iditarod Trail locations of WAMCATS could be found in Nome, Nulato, Fort Davis, Seward, Unalakleet, and Kaltag. Following local tradition, some contemporary mushers desiring good luck still leave behind a small gift of food for the Old Woman to keep her ghost happy. (LC.)

Along the waters of Resurrection Bay at Seward, a small park surrounds this simple monument marking Mile Zero of the Iditarod Trail. The Miners and Merchants Bank is no more, nor are there cargo ships bearing supplies to be shipped to the Interior goldfields. However, the city remains an important stop on the Alaska Railroad, the southernmost depot on a line that ends in Fairbanks, a line that remains disconnected from any other railway in Canada or the United States. Today, Seward's docks are filled with recreational boats, commercial fishing vessels, tourism day boats, and vast cruise ships.

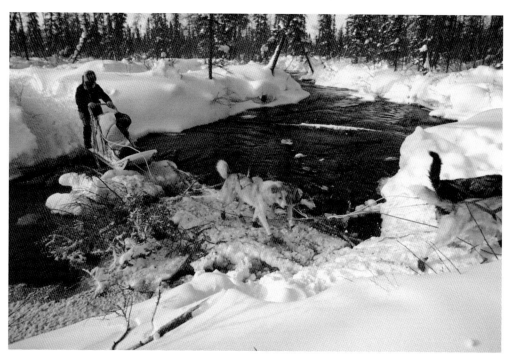

Emmitt Peters and his team got their feet wet in the 1990 race while crossing this open stream. Trailbreakers used brush and small limbs to create a corduroy bridge, but the area did not experience enough freezing temperatures to solidify the stream. (Jeff Schultz.)

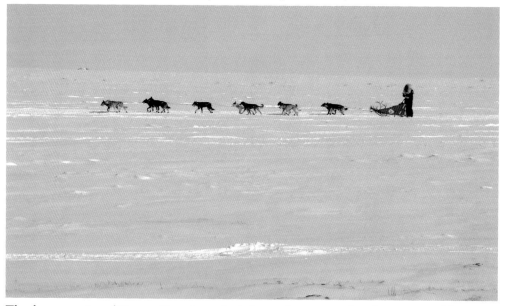

The frozen sea ice of Norton Sound can look featureless to a rookie, but veterans like Lance Mackey (pictured) recognize the nuances in the horizon. Tripod trail markers are erected in treeless areas, but sometimes those are blown out of position by the field winds of the coastal areas. (Theresa Daily.)

A THOUSAND MILES OF HAZARDS

Traveling up and over the Alaska Range is one of the first major obstacles on the trail. The Rainy Pass Lodge on Puntilla Lake is at an elevation of 1,800 feet at timberline. After leaving the checkpoint, mushers have more miles of uphill travel to Rainy Pass, the highest point on the trail (at 3,160 feet), before they descend. Here, Vern Halter negotiates the trail near the Rainy Pass checkpoint in 1997. (Jeff Schultz.)

Waiting beyond Rainy Pass is Dalzell Gorge, described in 1997 by then-race manager Jack Niggemeyer as "probably the most singularly terrifying thing on the whole race. Or it can be, depending on the weather." The route involves traveling downhill in a narrow canyon with switchbacks, sidehills, and occasional open water. In 1993, Dewey Halverson (pictured) took on Dalzell Gorge like a bucking horse. (Jeff Schultz.)

The original Safety Roadhouse (pictured above) sheltered travelers in the early 20th century, but it is no longer standing. The current checkpoint building had another life in the late 1930s as the Nomerama, where Nome residents went to watch motion pictures. The building was moved here in sections in the 1980s. From this point, it is just 22 miles of travel—mostly on the beach—to Nome. Here, mushers must once again don their number bibs for the last leg of the race. (LC.)

Mushers can help themselves to water supplies in village checkpoints. Sometimes they must venture to a winter waterhole on a river. At other checkpoints, villagers keep a barrel of water heating over a campfire, which is handy for mixing with the dogs' food to help keep them hydrated. In the 2004 image at left, Vern Halter is using soft-sided carriers to bring water back to his team at Takotna. (Jeff Schultz.)

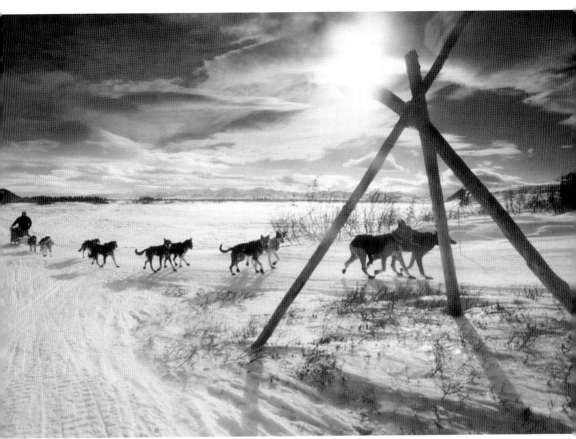

Old-school tripods are still used today to mark the trail on ice and in treeless areas. From January 31 to April 5, 1908, Col. Walter Goodwin and his party traveled by dog team to scout a winter trail between Seward and Nome. Colonel Goodwin wrote about the crew's trail-marking tripods in a 1912 article, "Trail Making in Alaska": "Tripods . . . consisted of three sticks of timber each, two of which were eight feet long and the third ten or eleven feet long. They are so fastened together that the longest of the tree sticks projects two or three feet over the others and directly above the trail." (Jeff Schultz.)

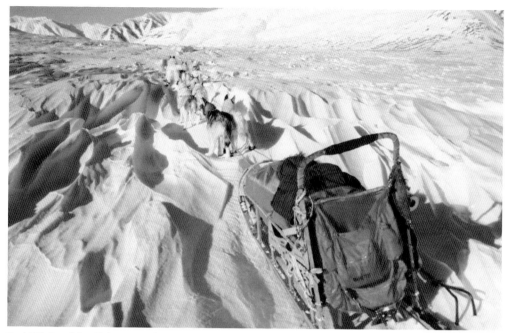

In 1979, Jon Van Zyle stepped off his sled at Rainy Pass to capture this photograph of his team in the heart of such a beautiful, wild place. He remembered 1979 as a very windy year and that he stopped to rest the dogs every four hours or so. (Jon Van Zyle.)

The Iditarod National Historic Trail logo includes an illustration of a husky designed by the late Bill Devine, whose artistry has been memorialized in Iditarod signage and memorabilia for over 40 years.

A THOUSAND MILES OF HAZARDS

7

EVERY DOG A HERO

In the late 19th century, as inexperienced gold miners stampeded into the Klondike, the value of a dog team—and especially a good leader—rocketed. Dogs of all shapes, sizes, and breeds were shipped north—some of them stolen off the streets of Seattle, many of them ill-suited to the climate. High dollars were exchanged for the best leaders and the biggest and strongest pack animals.

During the Nome gold rush a few years later, a more measured approach to developing a freight-hauling team involved breeding dogs to select for the positive traits of huskies, wolves, and a nebulous "breed" now known as the village dog. Sled dogs ideally have dense coats; tough feet; deep and broad chests; long, powerful legs; and the ability to withstand deep cold, deep snow, and long hauls. However, teams in the All Alaska Sweepstakes included thick-shouldered St. Bernards, Irish setters, malamutes and wolf-crosses, pointers, and those delicate-looking little workhorses known as the Chukchi Siberians.

In mid-20th-century Alaska, before the rise of the snow machines, it was as common to see clusters of three to five dogs near a cabin as it is to see an SUV in the driveway today. Among racers, the focus shifted from large (75 to 100-plus pounds) freighting dogs, who ran in the slow but steady lane, to dogs weighing in at less than 50 pounds—veritable lap dogs compared to their predecessors.

Mushers are correct when they say, "It's all about the dogs." As coaches, they value that intuitive bond with the animals, experience deep gratitude for the team that pulls them to Nome, and relish those long days of traveling through the wilderness and relying on each other. It is equally true that the fans often care more about the dogs than the mushers, and not just in an animal-rights sense. Americans are dog people.

Spectators watch with smiles as teams streak from the starting chute on hyperdrive, mushers standing on the brake and dragging an extra sled and person to help slow them. The pictures of the smiling, wolfish faces with the lolling tongues stay with those who witness them. These dogs, neither pets nor wild, are finely-tuned running machines in fur coats headed to places most people will never see—and they stir up the wild in everyone.

The distinctive markings of an Alaskan Malamute (left), an American Kennel Club–recognized breed, are often associated with classic sled dogs of the north. However, most mushers claim the best breed for running the Iditarod is the Alaskan husky (below), which is considered a mutt, as no two are alike. Many Alaskan kennel owners can trace the lineage of their pups to offspring of champion sled dogs. When pups are bred with champions on both sides, they can command a higher sale price—if they are for sale at all.

EVERY DOG A HERO

Champion bloodlines take on many forms in Alaskan huskies. Cael (left) and Salem live and train in Denali National Park. (Ellen Donoghue.)

Zig, a young, fun-loving Alaskan husky with 3/16 pointer in her bloodline, goofs off in her doghouse at the Husky Homestead. Co-owned by Jeff King and Ellen Donoghue, she looks like anything but a team leader, with a coat that is more hound than husky. Yet in 2013, as a yearling, she made King's third-place Iditarod team and his first-place Kobuk 440 team, running in lead for sizeable portions of both races. (Quinn Mawhinney.)

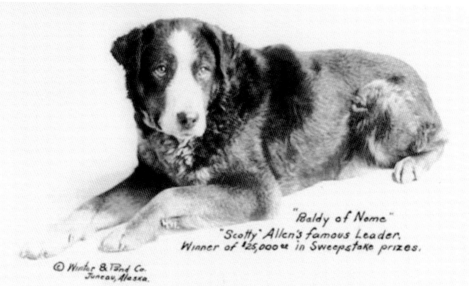

"Baldy of Nome"
"Scotty" Allen's famous Leader.
Winner of $25,000 in Sweepstake prizes.

© Winter & Pond Co.
Juneau, Alaska.

In the early 20th century, a mutt named Baldy belonged to a Nome-area boy who could not afford him and reluctantly accepted Scotty Allan's charitable offer of $25. In no time, the dog proved himself an extraordinary leader who took Allan's team to an All Alaska Sweepstakes victory in 1909. In another race, the Solomon Derby, Baldy sensed that his musher was not on the runners and turned the team around to find Allan bleeding and unconscious on the trail, then barked and licked him until Allan awakened. The musher refused top dollar for Baldy when the French army wanted the dog for their military operations in the mountains of France. This image is from the book *Baldy of Nome* by Esther Birdsall Darling. (Photograph by Winter & Pond.)

EVERY DOG A HERO

Leonhard Seppala had high regard for the little purebred powerhouses, the Siberian imports from Russia, and made the breed the focus of his program starting in 1914. Seppala's Siberians—including Togo (top) and his half-brother Fritz (left), both part of the dog-team relay that carried diphtheria serum to Nome in 1925—traveled by ship a year later when Togo and 47 other Seppala dogs made a cross-country promotional trip. Seppala called Togo "the best dog that ever traveled the Alaska trail." Togo lived to age 16, finishing his last years in Maine. This image is from the book *Seppala: Alaskan Dog Driver* by Elizabeth M. Ricker.

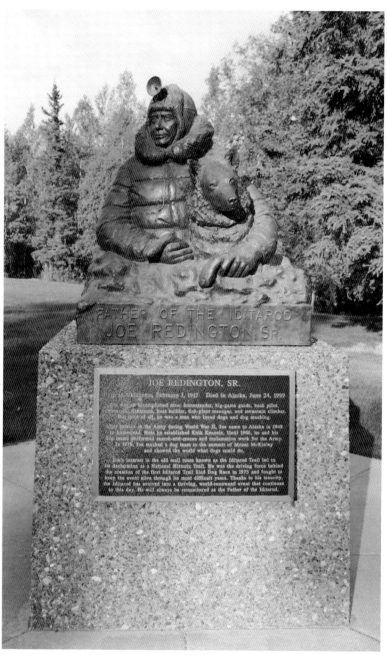

Joe Redington Sr. owned hundreds of dogs through the years. Two of them, Roamer and Feets, were standouts in his memory. During one sitting, Iditarod artist and photographer Bill Devine made several formal portraits of Redington holding Feets. One image was eventually used in the creation of a bronze statue that was unveiled in front of Iditarod Trail Committee Headquarters in Wasilla on February 1, 2003, as a memorial to Redington. A smaller version of the statue, which includes a working headlight, is part of a trophy that has been awarded to the Iditarod champion each year since 2000.

EVERY DOG A HERO

Ten years after arriving in Alaska as a schoolteacher, Dan Seavey was helping the Iditarod race to get off the ground. In 1974, during his second race, he ran with Kiana and Sonny (both pictured here with Seavey in 1974) in lead and finished in fifth. "I admit to being a hardcore Iditarod junkie," Seavey says. (Dan Seavey Collection.)

Emmitt Peters' favorite leader was an old girl named Nugget. She was 10 in 1973, when Peters loaned her to Carl Huntington; Nugget led Huntington to first place at the World Championship Dog Sled Race. Huntington borrowed her again for the 1974 Iditarod. Once again she helped him land in first, but this time in distance. When Peters decided to do the Iditarod in 1975, he put Nugget—then nearly 13—in double lead with a youngster, but the young dog grew tired. After hearing Peters' story, 1989 Iditarod champ Joe Runyan wrote: "the grandmother of many of the dogs in the team took command in single lead, taking Emmitt Peters along the windblown coast to the finish in Nome and secured a second Iditarod victory in 14 days, 15 hours—a record that stood for the next five years." Nugget was Runyan's nomination for "top dog of the century."

Rick Swenson's Andy was a standout dog who led him to victories in 1977, 1979, 1981, and 1982. Andy was in lead when Swenson won the All Alaska Sweepstakes in 1983. A year later, Swenson loaned Andy to Sonny Lindner, and Andy led Lindner to the championship in the inaugural Yukon Quest. After his death (three days shy of 20 years old), Andy was mounted and now stands inside the ITC Headquarters, memorialized as one of the greatest dogs ever to race. (Jeff Schultz.)

Granite, pictured here with owner Susan Butcher (Granite is the dog on the right), achieved legendary status even before his death. The big dog was nothing to speak of when Joe Redington Sr. urged Butcher to pick a dog from his lot to pay off a debt. Granite had patchy fur and was underweight, but he had charisma. He flourished under Butcher's care and led her to three consecutive Iditarod championships in 1986, 1987, and 1988. Granite was such a vital member of the family that he served as ring bearer when Butcher married David Monson. Butcher and Monson wrote a children's book, *Granite*, about the dog's comeback story; it is a seasonal bestseller in Fairbanks. (Jeff Schultz.)

EVERY DOG A HERO

Robert Sørlie's Kvitsokk (translated as Whitesock) was the 2005 Golden Harness winner, leading Sørlie to his second championship (in 2003, his dog Tipp won the award). While thanking Kvitsokk publicly, Sørlie said, "He's the typical lead dog that makes a team give that little extra. Dogs like this are one in a thousand and is the type we lack today. The dogs that from early in a race sets the pace, even in the toughest of courses." (Robert Sørlie.)

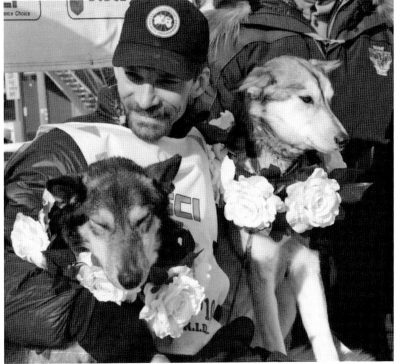

Lance Mackey's Larry and Hobo Jim won the Golden Harness Award at the Yukon Quest in 2005 and 2006; Larry won the Golden Harness (for outstanding lead dog) at Iditarod in 2007. (Theresa Daily.)

Zorro was a favorite trail mate of Lance Mackey. In the 2008 All Alaska Sweepstakes, Zorro was nearly killed when he was hit by an inebriated snow machine driver. After surgery, the dog's love for his musher seemed to bring him back from the edge, and he eventually died of old age at Mackey's Comeback Kennel. Mackey told a Discovery Channel reporter: "Lead dogs are not 'chosen' to be leaders. They are either born with the drive to lead, or they are not, and from that, only a few become great leaders. Like Larry or Zorro." (Theresa Daily.)

A member of Allen Moore's team howls before leaving the 2013 start line in Anchorage. Moore and his wife, Aliy Zirkle, operate SP Kennel in Two Rivers, near Fairbanks, home to more than 50 sled dogs that the couple trains and races in both the Iditarod and Yukon Quest. Moore won the 2012 Yukon Quest.

EVERY DOG A HERO

Jeff King gave credit for his 2006 first-place Iditarod finish to his leader, Salem, a dog who had turned the team around and returned to his musher when King became separated from the team in a fierce storm. Salem has shown his leadership skills in race after race, King said. "One of the top moments of my life was going through Aniak in the Kuskokwim 300 with him in lead as a two year old," King said. "He was screaming to go, 200 miles into the race. Charlie Boulding's wife asked me, 'How do you do it?' I said, 'I don't know.' We left there shooting up a rooster tail of snow." In his teens, Salem retired from competition and was given responsibility for running with the "puppy teams," training youngsters that are new to the harness. (Lisa Frederic.)

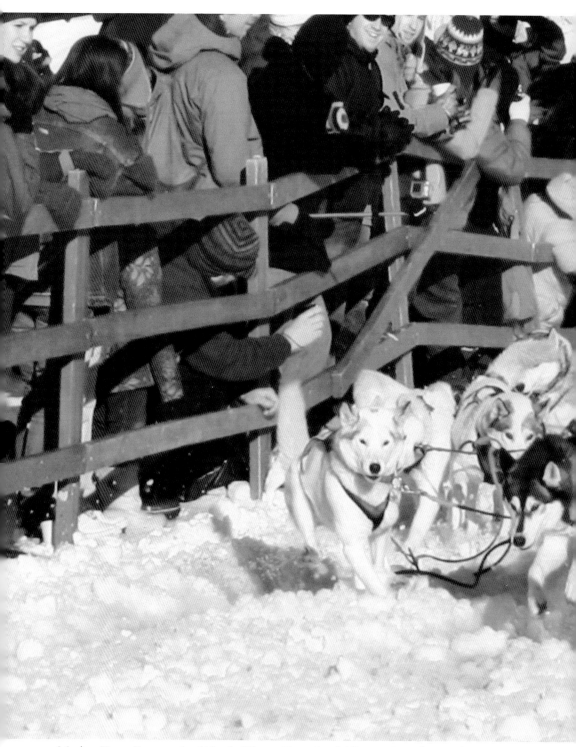

Musher Karen Ramstead, of North Wapati Kennels of Alberta, Canada, raced with a purebred Siberian team, evoking the spirit of the great Leonhard Seppala, who had deep admiration for

EVERY DOG A HERO

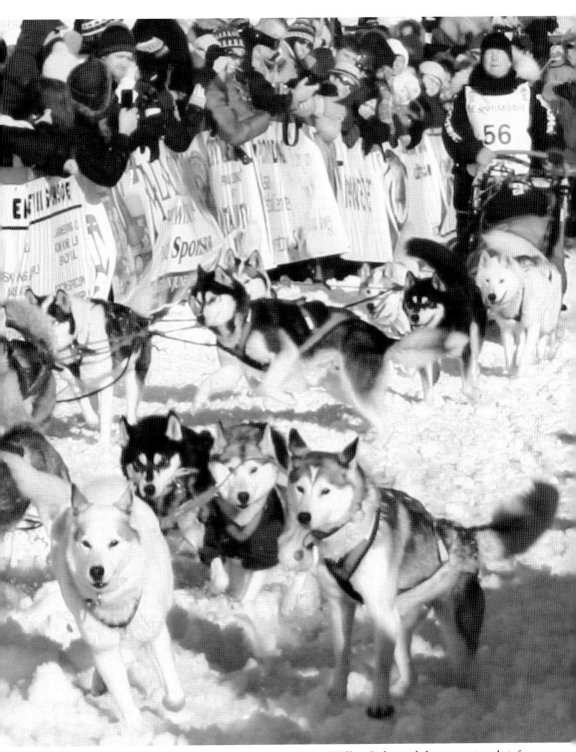

the breed. In this image, she is leaving the 2012 restart on Willow Lake with her team in a brief tangle of disorder.

Sled dog breeders have long known that the more a puppy is handled in its early months, the more calm the animal will be in situations that involve strangers—like pulling into a busy checkpoint after hours on a desolate trail. Mushers who interact with tourists in the summer months—such as the Seaveys, Martin Buser and DeeDee Jonrowe, Jeff King, Mike Santos, John Baker, Vern Halter, and others—have a method for teaching the dogs to associate strangers with kind attention; they allow strangers to cuddle and pet the dogs several times each day.

EVERY DOG A HERO

WOMEN ON THE RUNNERS . . . AND WINNING

The first Iditarod roster was filled with men. In 1974, however, two mushing women elbowed in, signed up, and finished the race. Mary Shields and Lolly Medley endured their share of friendly jeering, but they were not making any sweeping statements about women's rights—they simply wanted to do it. Shields and Medley both finished, while 18 of the 44 entrants that year withdrew or scratched. Since then, a host of women have entered the Iditarod.

One of the best-known slogans in mushing is "Alaska: Where Men are Men and Women Win the Iditarod." The women who inspired those words were Libby Riddles, who, in 1985, became the first woman to win, and Susan Butcher, who shattered the notion that the Iditarod was a man's race.

The Iditarod is now viewed a great equalizer—casting light on variables such as fitness, dog care and nutrition, attitude, efficiency, and ambition. Throw in the odd storm or bad intersection with a wild animal, and every musher has Las Vegas odds.

In 1985, Riddles mushed out of Shaktoolik into a fierce coastal storm while others hunkered down. Her history-making gamble paid off, and her bravery—coupled with her fresh good looks—sold newspapers and national magazines. Close to three decades later, Riddles still writes and speaks about her Iditarod experience with Alaska visitors.

Many believe Butcher was on track to win in 1985 if not for a tragic encounter with a moose that trampled her team, injuring several team members. Devastated, Butcher scratched. In the years that followed, however, she dominated the race, winning three in a row (in 1986, 1987, and 1988), taking second in 1989, and winning again in 1990—a phenomenal achievement.

The ever-popular DeeDee Jonrowe has placed in the top ten 16 times. Crowds also follow her fight in another endurance test—beating cancer while hardly missing a beat in her mushing career. Jonrowe used to dress in the same dull layers of insulated pants, parkas, and boots as her competitors. But since her fight with breast cancer, she has worn a fluffy, girly, pink kuspuk (a long parka with a flounce), and dressed her dogs in pink booties, harnesses, and coats—even her dog truck was pink. It turns out that pink can be a powerful color.

Mary Shields
Sled Dog Trails

Illustrations by Nancy van Veenen

Mary Shields started the 1974 Iditarod with eight dogs, the smallest team in the field, led by her beloved Cabbage. She arrived in Nome in 23rd place, becoming the first woman to finish the race. At the line, about 30 parka-clad women were there with a banner that read, "You've Come a Long Way, Baby." Still, Shields regretted that the race did not allow more time for visiting friends along the trail, so when it was over, she rested her team, then turned around and mushed back toward Fairbanks—finally, she could take her time. (Pyrola Publishing.)

In 1974, Lolly Medley could not remember when Mary Shields got by her, just that Shields was already in Nome when Medley arrived 29 minutes later to claim 24th place. The trip had taken 28 days, 19 hours, 25 minutes, and 30 seconds. Medley was so inspired by the dogs and their performance that she instituted a new award: the Golden Harness, which honors the outstanding lead dogs of each race as chosen by mushers. The award began in 1976 with harnesses that Medley made. Through the years, mushers have been deeply honored by the award. Medley died of colon cancer at age 50, but the award she created is still handed out each year. (Ramey Smyth and Becca Moore.)

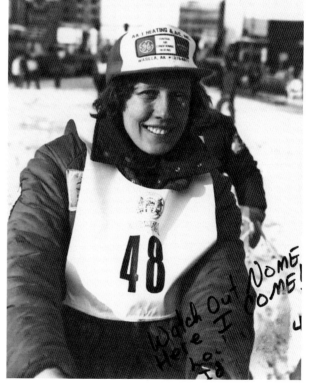

Libby Riddles broke the gender barrier in 1985 with a stunning, strategic move to run into a virtual whiteout when her competitors were pinned down in a shelter cabin. Riddles moved to Alaska and started acquiring dogs in 1974 with, as she put it, "no intention of racing." After a couple of years, a friend talked her into trying a five-dog race, and she won. "Then I started thinking maybe I could run the Iditarod," she said. (Jeff Schultz.)

The adage "always a bridesmaid, never a bride" seems to apply to DeeDee Jonrowe, a good-natured, popular musher who also has the competitive nature of a reality-show contestant. Though she has never taken first place in the Iditarod, Jonrowe has proven herself and her dogs as worthy opponents year after year with 16 finishes in the top ten and half of those in the top five. (Jeff Schultz.)

After being diagnosed with breast cancer in 2002, Jonrowe followed doctors' orders but continued to find herself at the Iditarod starting line each March. She has become an inspiration for cancer survivors from all walks of life and a tireless fundraiser for the cause. Highly visible in her pink parka, Jonrowe draws a crowd wherever she goes.

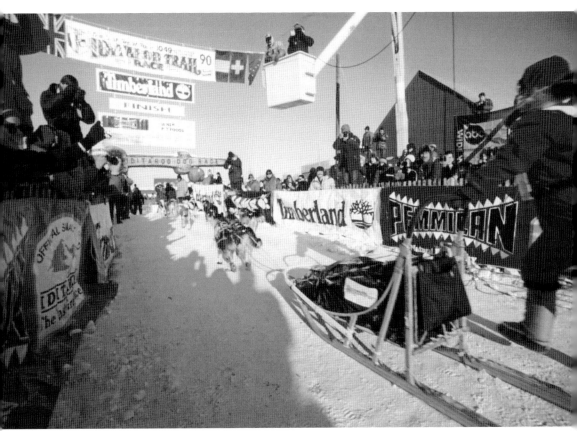

Susan Butcher slides down Front Street toward the Burled Arch during her 1990 first-place finish—the fourth championship for the musher from Manley, Alaska. In 1979, Butcher and Joe Redington Sr. were the first to mush dogs to the summit of the 20,320-foot Mount McKinley, North America's highest peak, with journalist Rob Stapleton and help from climber and guide Ray Genet. She was the first woman to place in the top 10 and the first of any musher to win three consecutive Iditarods. Butcher held the race record for speed (11 days, 1 hours, 53 minutes), until it was smashed by Martin Buser in 2002. She briefly dropped out of racing when she and her musher husband David Monson chose to start a family. Butcher fell ill with cancer in the early 2000s, succumbing to the disease in 2006. (Jeff Schultz.)

Sporting a smile as wide and familiar as Susan Butcher's, Aliy Zirkle of Two Rivers, Alaska, is a contending musher who consistently runs in the top five and offers fans a healthy dose of excitement, like in 2012, when she leapfrogged with Dallas Seavey for miles before landing in second place. In 2013, she wrestled for first place with Dallas's father, Mitch Seavey, again landing in second with only a half-hour difference between their times. She is married to another distance musher, Allen Moore, who won the 2013 Yukon Quest. Below, Zirkle, a crowd favorite, waves to fans as she glides down Fourth Avenue during the 2012 ceremonial start. In 2000, Zirkle won the 1,000-mile Yukon Quest, which runs from Fairbanks to Whitehorse, and stands as the only woman to win that race to date.

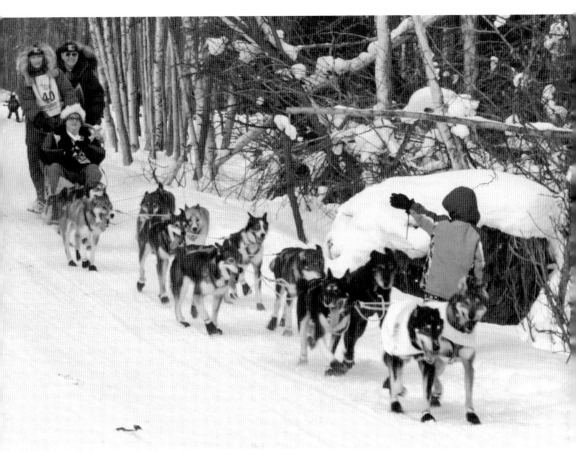

Angie Taggart is the first person from Ketchikan, male or female, to complete the Iditarod. It is not easy to train when you grow up in a rainforest in one of Alaska's southernmost towns. In 2011, Taggart ran her first Iditarod in 13 days, 1 hour, 49 minutes, and 24 seconds, which made her finishing time better than that of every Iditarod musher who competed from 1973 to 1981. She finished in 43rd place.

The Berington twins, Anna and Kristy, pose with their sister Kat (center) at the 2013 Musher's Drawing Banquet. The twins operate a kennel called Seeing Double Sled Dog Racing in Kasilof, on the Kenai Peninsula. The Beringtons grew up on the southern shores of Lake Superior in Wisconsin, an area that fed their interest in racing sled dogs. After moving to Alaska in 2007, they were mentored by 1984 Iditarod champion Dean Osmar. Anna continues to train with Osmar, while Kristy works with Iditarod veteran Paul Gebhardt. The women mush in short- and middle-distance races and both completed the 2012 and 2013 Iditarods.

Jan Steves packs her Trail Mail in the sled bag before the start of the 2013 Iditarod. Steves finished last that year, earning the Red Lantern Award, which is given to the musher who is last to cross the finish line in Nome. A lantern hanging from the Burled Arch at Nome remains lit until the last musher crosses the finish line. Finishing the race, even in last place, is still a rare achievement.

Champions and Record Breakers

In a race as long and as grueling as the Iditarod—and one that has been around long enough to amass a lot of statistics—it can be entertaining to crunch numbers and look for anomalies.

For instance, who finished with the most number of dogs in 2001? Karen Ramstead started with 16 Siberian Huskies and ended the race with 15. In what year were teams of two human racers allowed? 1973. According to Dick Mackey, the rule was set out in the flimsy hope that wives might want to join their husbands. Why is the Iditarod labeled as a "1,049-mile race" when it is actually about 1,100 miles? The organizers had originally proposed a thousand-mile race, and the 49 is for Alaska, the 49th state.

In 2002, Martin Buser broke the nine-day time barrier with leaders Bronson and Kira, winning his fourth Iditarod title in 8 days, 22 hours, 46 minutes and 2 seconds. In 2011, John Baker shaved three hours off Buser's record.

All the statistics are interesting, but for some fans, the oddities can be especially intriguing:

- The slowest musher in Iditarod history is John Schulz, who finished the 1973 race in 32 days.
- Based on his 2011 running time, Ramey Smyth could mush to Nome and back and still spend a weekend at the hot springs in the time it took 1973 champion Dick Wilmarth just to get to Nome.
- The only mother and daughter to have finished the Iditarod are Barb Moore, who ran in 1980 and won the Red Lantern, and her daughter, Lisa, who completed the race in 1996.
- The youngest musher to enter was Dallas Seavey, who ran in the 2005 Junior Iditarod at age 17, then turned 18 one day before the Iditarod and ran that race in the same year.
- Dallas Seavey was also the youngest musher to win, taking the 2012 championship at age 25.
- The closest finish was in 1978, when Dick Mackey edged out Rick Swenson by one second—the winner was determined by race officials who stated that the deciding factor was the nose of the dog that crossed first, not which musher was first to get his sled completely over the finish line.

Col. Norman Vaughan, pictured in 1989, began his Iditarod career in 1975 at the age of 72, when most people would not dream of such a challenge. Vaughan, however, was hardly ordinary. As a young man, he accompanied Adm. Richard Byrd to the South Pole as a dog driver; this was just the beginning of a life filled with achievements, including, in his senior years, climbing the South Pole peak that Byrd named for him. Vaughan finished 4 of the 13 Iditarods that he entered, living by his motto: "Dream big and dare to fail!" Vaughan died in 2005, just days after his 100th birthday. (Jeff Schultz.)

Rick Swenson, the only musher to win five times, has had his record challenged, but it still stands. Swenson took first place in 1977, 1979, 1981, 1982, and 1991. Each year, fans watch to see if one of the contenders with four wins—Doug Swingley, Jeff King, Martin Buser, and Lance Mackey—will break into Swenson's party of one. Susan Butcher, the only female four-time winner, passed away in 2006.

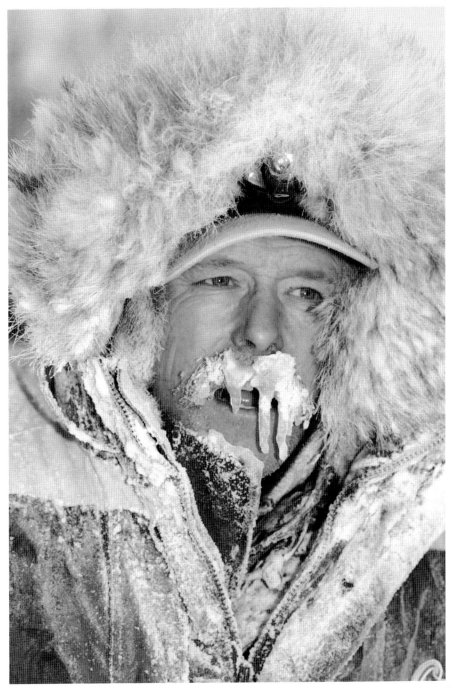

Jeff King is called "the winningest musher" for his four Iditarod championships, a Yukon Quest championship, and more than two dozen first-place finishes in other races, including the Kuskokwim 300, the Kobuk 440, the Copper Basin 300, and more. His Husky Homestead in Denali Park is a popular tourist attraction where he shares trail stories and introduces thousands of visitors, young and old, to his canine stars. (Jeff Schultz.)

In 2002, Robert Sørlie of Norway was chosen as Rookie of the Year, and the next year, he moved into first place, becoming the first winner from overseas to take the championship. He won again in 2005, proving that the first time was no fluke. (Kjersti M.G. Mjærum)

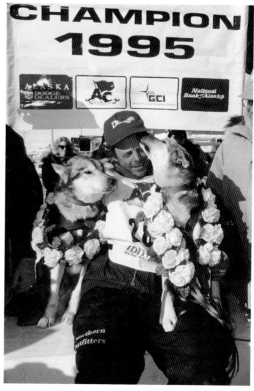

Doug Swingley of Montana chalked up a first in 1995, becoming the first non-Alaskan to win the race. He also broke the 10-day barrier that year, finishing in 9 days, 2 hours, 42 minutes, and 19 seconds. Swingley won again in 1999, 2000, and 2001. (Jeff Schultz.)

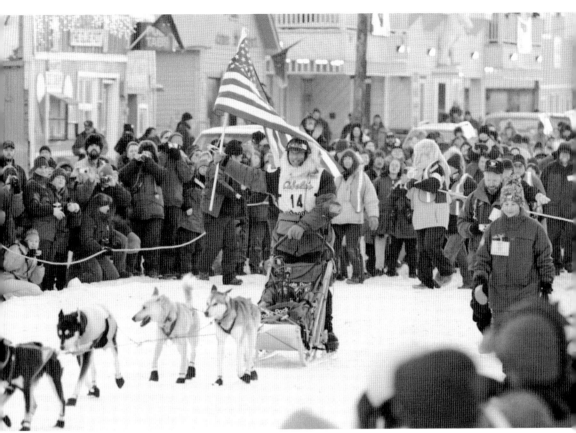

In 2002, Swiss-born Martin Buser broke the speed record and claimed first place, then swore his oath of citizenship at Nome in a moving ceremony that had much of the crowd in tears. Standing with his wife, Kathy Chapoton, and sons, Rohn and Nikolai (each named for Iditarod checkpoints), Buser repeated the oath administered by Alaska Superior Court judge Ben Esch and later told a reporter from the *Anchorage Daily News*: "Now I'm legal. . . . Now I'll get to vote." Buser won the race in 1992, 1994, 1997, and 2002. (Jeff Schultz.)

Lance Mackey blew the doors off the popular opinion that a musher and team could not run two 1,000-mile races back to back. He ran and won the Yukon Quest International Sled Dog Race in 2007, then, two weeks later, entered and won the Iditarod. In 2008, he did it again. He added a new category to the record book by winning the Iditarod again in 2009 and 2010, earning four consecutive wins. Furthermore, all of his greatest accomplishments occurred following extensive surgery and chemotherapy for throat cancer.

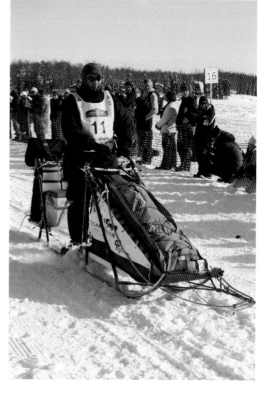

John Baker said that he was not aiming to break records when he won the 2011 race in 8 days, 18 hours, 46 minutes, and 39 seconds—knocking three hours off Martin Buser's previous record—but he did it. An Iñupiaq man from Kotzebue, Baker arrived at the finish line amid Alaska Native drumming and raucous cheers and hoots, especially from the locals. Besides setting a new record, he had delivered the title for an Alaska Native fan base that watched an Iñupiaq musher win the Iditarod for the first time. Baker is pictured leaving Willow during the 2012 race.

10

PASSING IT FORWARD

Raising kids in a mushing family is no guarantee that the next generation will pick up where mom or dad left off. However, the Redington, King, Seavey, Mackey, Butcher, and Buser families, among others, continue to thrive in the dog yard.

Likewise, families who have served in volunteer positions with the Iditarod have demonstrated the spirit of giving to the race with their time and talents. Sons and daughters have volunteered alongside their parents and then taken over at a checkpoint, or at the controls, or behind a desk; they grew up with the Iditarod.

But Alaska's dog-mushing roots go back much further than 1973, and one family in particular has a deep taproot. In the late 1800s, Arthur Wright was an Athabascan interpreter for Episcopal priest Rev. Hudson Stuck, and they traveled around Alaska by dogsled. Wright's son, Gareth, became a celebrity throughout Alaska's sprint-racing world, winning two North American championships and three Fur Rendezvous World Championships (in 1950, 1952, and 1957). The next generation—Gareth's daughter, Roxy—also achieved great success and won numerous North American championships and Fur Rendezvous World Championships. She married another sprint champion, Charlie Champaine, and their son Ramy Brooks has been involved in several Iditarods. Ramy's daughter Abigail competed in the Junior Iditarod, but told an interviewer that, in all honesty, she was not sure she would keep after it; it just was not her thing.

Then there are those who spring up from nowhere, who drive up the Alaska Highway with a few dollars in their pockets, like Joe Redington Sr. or Susan Butcher or a Swiss man named Martin Buser, just following a dream. Like hopeful actors and actresses who leave small towns for New York or Hollywood, the dog people are drawn to Alaska. They are born to it without being born into it.

Like sled dog bloodlines, sometimes champion genealogies matter—sometimes they do not.

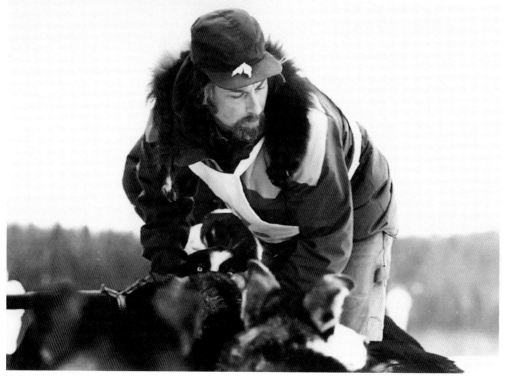

Joe Redington Sr. lost his battle with esophageal cancer on June 24, 1999, at age 80, and was memorialized in the *Iditarod Runner* with a Bill Devine portrait on the cover. By request, Redington was buried in a dogsled in a private ceremony. Gov. Tony Knowles ordered the flags flown at half-mast across the state, and nearly 700 people gathered outside the ITC Headquarters to remember "Old Joe." (ITC.)

Joe Redington Jr., known as Joee, was a prominent name in sprint-mushing circles in the 1960s. He joined his dad and brother Raymie in the 1967 Centennial Race. (Clark Fair.)

Raymie Redington also built a strong reputation as a champion sprint musher before entering long-distance mushing. In recent years, he has also provided dog-powered cart rides for visitors to the Iditarod Trail Committee Headquarters outside of Wasilla, sharing stories of growing up the Redington way.

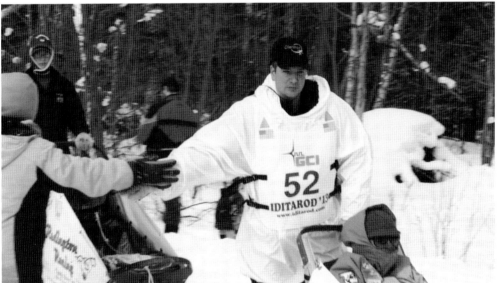

The Redington family tradition continues in another generation—Joe Redington Sr.'s grandsons are now Iditarod veterans. Here, Ray Jr., the son of Raymie Redington, gives a high-five to a young fan along the 2013 ceremonial trail through Anchorage. Ray Jr. went on to finish in the top 10. Ray Jr. met his wife when they were both competing in the Junior Iditarod (for mushers younger than 18 years old). They live in Knik on land they purchased from his grandparents' estate.

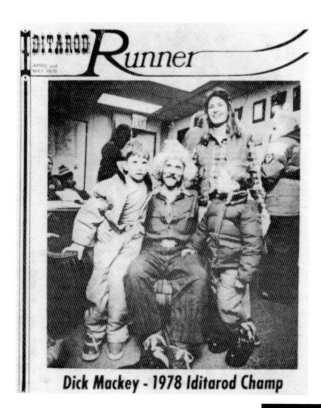

Dick Mackey - 1978 Iditarod Champ

In 1978, the year that Dick Mackey beat Rick Swenson by a mere second, this cover of *Iditarod Runner* featured a Mackey family portrait. Dick is pictured with his son, Lance, the future four-time champion, to his right, and another mushing son, Jason, to his left. Lance and Jason's mother, Kathi Mackey (also pictured), was a sprint musher who competed even while pregnant with Lance. (ITC.)

Dick Mackey, patriarch of the Mackey mushing clan, is pictured here at the Mushers' Drawing Banquet in 2013, where he watched as his son Lance drew a starting number and made a speech. Lance has had an illustrious career, but he is not the first Mackey son to succeed. In 1983, Lance's half-brother, Rick, claimed an Iditarod championship; Rick's daughter Brenda has competed as well.

PASSING IT FORWARD

In this 2012 photograph, Lance Mackey is leaving the restart line wearing Bib No. 18. Lance grew up aspiring to be as good a musher as his father, Dick, and his half-brother Rick. In a strange coincidence, the Mackey men each won an Iditarod while wearing Bib No. 13—Dick in 1978, Rick in 1983, and Lance in 2007.

Big Lake musher Martin Buser (pictured at left) and his wife, Kathy Chapoton, raised two sons, each of whom was named for an Iditarod checkpoint—Rohn and Nikolai. Both boys enjoyed the sport, but Rohn, especially, has followed in his father's footsteps.

Martin Buser and his son Rohn (pictured at right) have mushed together in races where it may have seemed that Martin was holding back to train his son. More recently, however, they have become true competitors against the pack and each other.

PASSING IT FORWARD

Bud Smyth leans in to wish his son, Ramey, good luck in the 2013 Iditarod. Ramey and Cim Smyth and their sister, Laura, were born to Bud and Lolly Medley, both mushers who imbued the love of the sport in their children. Ramey was born two years after his mother finished the Iditarod in 1974; she was one of the first two women to enter the race. (Courtesy Ramey Smyth and Becca Moore.)

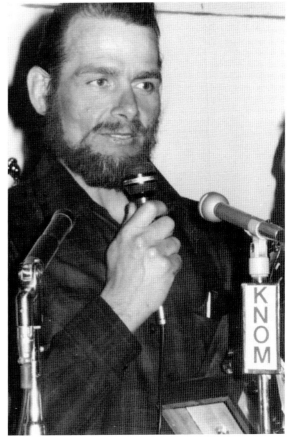

Dan Seavey addresses the audience at the Nome Finishers' Banquet of 1973—the first of its kind. Seavey was in the field of mushers who embarked on the first running of the 1,000-mile race. He ran it again in 2012, when three generations of Seaveys participated in the Iditarod's 40th anniversary race; Dallas Seavey, the youngest, won. (Dan Seavey Collection.)

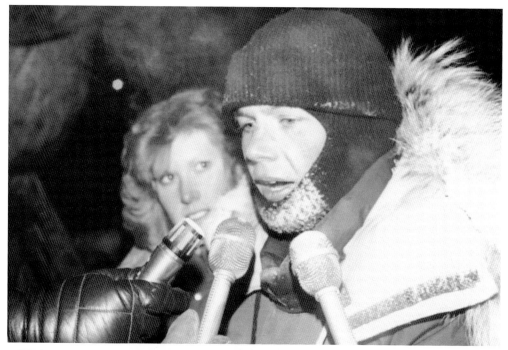

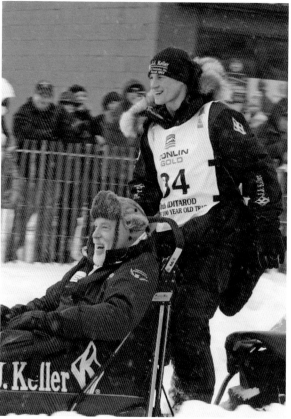

Mitch Seavey was a boy when his father, Dan, entered the inaugural race in 1973, and he was determined to run it himself someday. In 1982, his dream came true. He is pictured with his wife, Janine, at the finish line of his first Iditarod. After 11 more runnings, Mitch won the race in 2004, and four years later he claimed the winner-take-all $100,000 prize for winning the All Alaska Sweepstakes' 100th anniversary race. In 2013, he won the Iditarod championship again. (Dan Seavey Collection.)

Dallas Seavey (standing) is one of four sons born to Mitch and Janine. Three of the sons—Dallas, Danny, and Tyrell—have run in both the Junior Iditarod and Iditarod races. In 2012, when Dallas won the Iditarod, his youngest brother, 15-year-old Conway, won the Junior Iditarod.

PASSING IT FORWARD

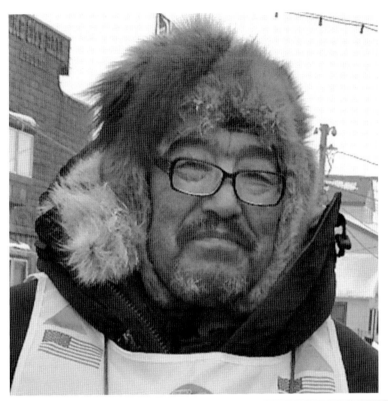

In 2013, Mike Williams Sr. ran in his 15th Iditarod, but it was the first time that he and he son ran it together. At race's end, he received the Most Inspirational Musher award. (Kaiser Racing Kennel.)

A Yup'ik man from Akiak, Mike Williams Jr. ran in the 2010 Iditarod, following in the tracks of his father, Mike Williams Sr. He told a journalist, "In one of my first memories of running dogs, I was sitting in the sled with my father, Mike Sr., on a training run. . . . I've always been interested in racing and running sled dogs. It is what I've dreamed about since I could remember . . . racing, mushing, and being out on the trail." He honors the advice that his dad and other mentors have given: take care of the dogs, and they will take care of you. (KYUK-FM.)

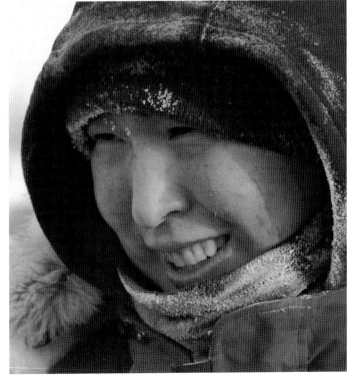

Some of the Iditarod's earliest volunteers are still involved as helpers and fans, passing the volunteering tradition on through their family and friends. Pictured here during the 2013 ceremonial race are, from left to right, (standing) Raine Hall, Gail Phillips, Kim Phillips, Lynette Clark, and Walt Phillips; two of Gail and Walt's grandchildren are pictured in front of the adults. Hall was the Iditarod's first paid employee and editor of the *Iditarod Runner* (among other duties); Gail and her husband, Walt, were active from the first years of Iditarod onward, working in various roles as Iditarod Trail Committee Board members, treasurer, secretary, race coordinator, banquet organizers, and even race-bib makers. Their daughters, Kim and Robin (not pictured) grew up volunteering alongside their parents. The Phillips' example has rubbed off on hundreds over the years; first-time volunteer Clark traveled from Fairbanks to help bundle and deliver the Trail Mail that mushers had to carry to Nome—she is planning to sign up again in 2014.

PASSING IT FORWARD

Alaska's love affair with mushers extended as far as a paint job on this Alaska Airlines Boeing 737-400. Designed by a 16-year-old Sitka high school student in 2009 to celebrate the 50th anniversary of Alaska's statehood, the illustration features a musher pulled by a husky, plus a ferry, a canoe, a bear, and a whale. The accompanying motto reads: "We're all pulling together." Alaska Airlines is a major sponsor of the Iditarod. (Alaska Airlines.)

RECOMMENDED READING

Brown, Tricia, and Debra Dubac. *Musher's Night Before Christmas*. Gretna, LA: Pelican Publishing, 2011.

Brown, Tricia, and Jeff Schultz. *Iditarod Country: Exploring the Route of the Last Great Race*. Seattle, WA: Epicenter Press, 1998.

Brown, Tricia, ed. *Iditarod Fact Book*. Seattle, WA: Epicenter Press, 2006.

Butcher, Susan, and David Monson. *Granite*. Fairbanks, AK: Trail Breaker Kennel, 1997.

Freedman, Lew. *Father of the Iditarod: The Joe Redington Story*. Seattle, WA: Epicenter Press, 1999.

Freedman, Lew, and DeeDee Jonrowe. *Iditarod Dreams: A Year in the Life of Iditarod Sled Dog Racer DeeDee Jonrowe*. Seattle, WA: Epicenter Press, 2005.

Freedman, Lew, and Jeff Schultz. *Iditarod Silver*. Seattle, WA: Epicenter Press, 1997.

King, Jeff. *Cold Hands, Warm Heart: Alaskan Adventures of an Iditarod Champion, 2nd ed.* Denali Park, AK: Husky Homestead Press, 2011.

Lewis, Albert. *Born to Run: Athletes of the Iditarod*. Anchorage, AK: Albert Lewis, 2013.

Mackey, Dick. *One Second to Glory: The Alaskan Adventures of Iditarod Champion Dick Mackey*. Seattle, WA: Epicenter Press, 2001.

Mackey, Lance. *The Lance Mackey Story: How My Obsession with Dog Mushing Saved My Life*. Fairbanks, AK: Zorro Books, 2010.

Mangelsdorf, Katie. *Champion of Alaskan Huskies: Joe Redington Sr., Father of the Iditarod*. Anchorage, AK: Publications Consultants, 2011.

Paulsen, Gary. *Winterdance: The Fine Madness of Running the Iditarod*. New York, NY: Mariner Books, 1995.

Riddles, Libby, and Tim Jones. *Race Across Alaska: First Woman to Win the Iditarod Tells Her Story*. Seattle, WA: Stackpole Books, 1988.

Salisbury, Gail, and Laney Salisbury. *The Cruelest Miles: The Heroic Story of Men and Dogs in a Race against an Epidemic*. New York, NY: W.W. Norton and Company, Reprint edition 2005.

Schultz, Jeff, and Brian Patrick O'Donoghue. *Iditarod Glory*. Portland, OR: Graphic Arts Books, 2005.

Seavey, Dan. *The First Great Race: Alaska's 1973 Iditarod*. Anchorage, AK: Publications Consultants, 2013.

Shields, Mary, and Nancy van Veenan, illustrator. *Sled Dog Trails*. Fairbanks, AK: Pyrola Publishing, 1984.

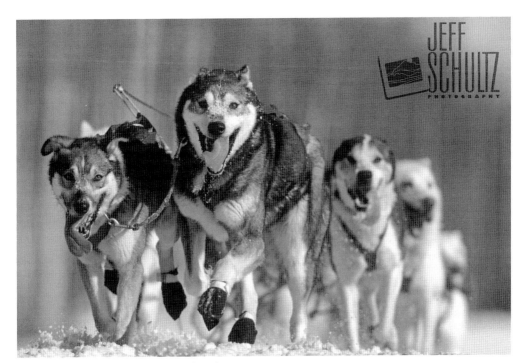

Jeff Schultz, whose photographs are found throughout this book, photographed his first Iditarod in 1981 at the request of Joe Redington Sr. After the race, Schultz donated his images to the Iditarod Trail Committee. He was asked to be the official photographer of the Iditarod the next year and has been ever since. Schultz travels the entire trail each year by plane and snow machine while attempting to capture as much of the action and Iditarod experience as he can. He shares his photographs online during the race at Iditarod.com. Over the past three decades, Schultz has amassed the largest collection of Iditarod photographs. He has photographed all the mushers, all the checkpoints, and all the trail conditions. Thousands of Schultz's Iditarod photographs, including slide shows of his best images, can be seen at iditarodphotos.com. Schultz also photographs on assignment in Alaska for corporate and editorial clients and shoots stock images. His portfolio can be found at schultzphoto.com.

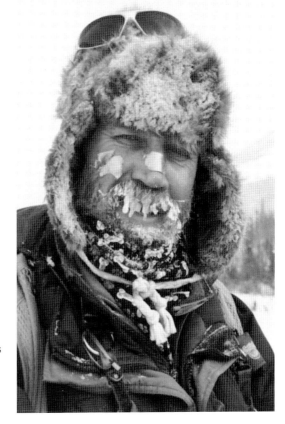

DISCOVER THOUSANDS OF LOCAL HISTORY BOOKS FEATURING MILLIONS OF VINTAGE IMAGES

Arcadia Publishing, the leading local history publisher in the United States, is committed to making history accessible and meaningful through publishing books that celebrate and preserve the heritage of America's people and places.

Find more books like this at
www.arcadiapublishing.com

Search for your hometown history, your old stomping grounds, and even your favorite sports team.

Consistent with our mission to preserve history on a local level, this book was printed in South Carolina on American-made paper and manufactured entirely in the United States. Products carrying the accredited Forest Stewardship Council (FSC) label are printed on 100 percent FSC-certified paper.

MADE IN THE USA